NO ORDINARY LAND

NO ORDINARY LAND

ENCOUNTERS IN A CHANGING ENVIRONMENT

VIRGINIA BEAHAN AND LAURA McPHEE

INTRODUCTION BY REBECCA SOLNIT / AFTERWORD BY JOHN McPHEE

APERTURE

THIS PROJECT IS MADE POSSIBLE BY GENEROUS SUPPORT
FROM RHETT TURNER AND THE TURNER FOUNDATION, INC.

How do people imagine
the landscapes they find themselves in?
How does the land shape the imaginations
of the people who dwell in it?
How does desire itself, the desire to comprehend,
shape knowledge?

—Barry Lopez, *Arctic Dreams*

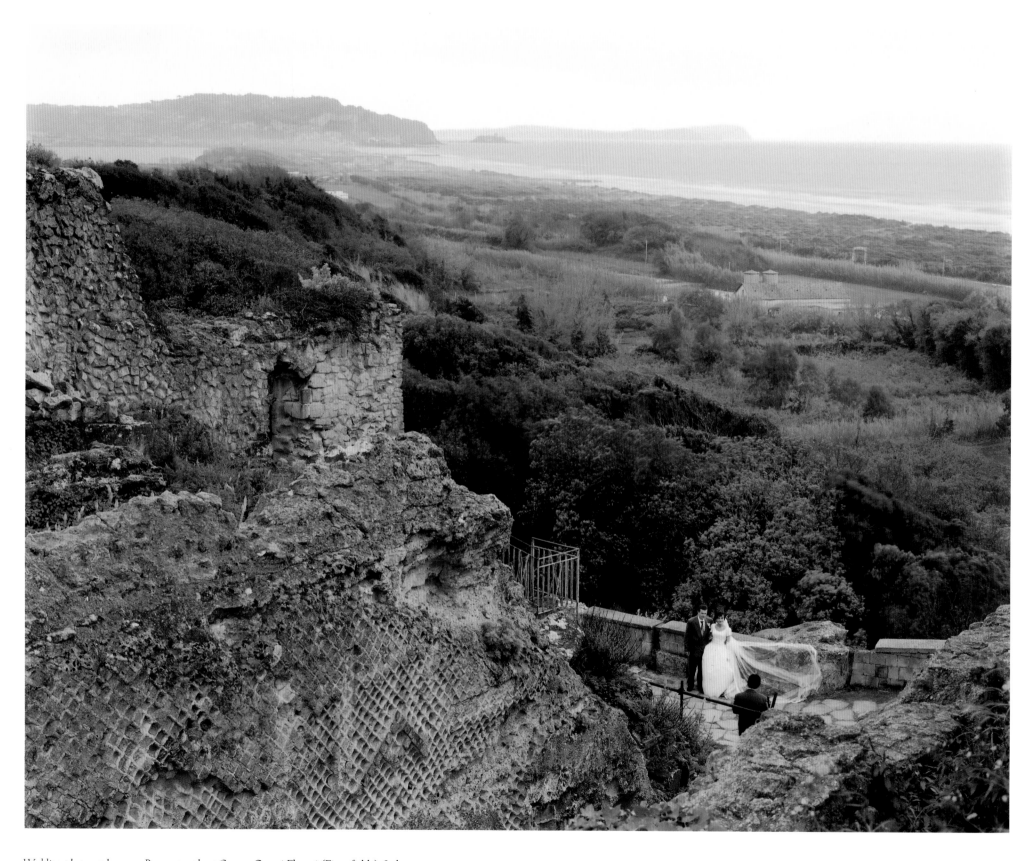

Wedding photograph near a Roman temple at Cumae, Campi Flegrei (Fiery fields), Italy, 1994

Indivisibility

Rebecca Solnit

Categorizing

A MAN STRAIGHTENS UP AFTER A DAY'S WORK IN THE STRAWBERRY fields of Watsonville. After so many hours stooped over the rows of dirt, leaves and fruit, the world looks big again, and he looks at the blueness of the sky, the clouds moving in from the Pacific not far to the west, the Santa Cruz mountains in the east, and the subdivision at the edge of the field. As he waits for a friend to sort something out, he lets his eyes rest on the Virgin of Guadalupe charm hanging from the rearview mirror. His mind drifts again, first to his friends who work in the rose fields up the coast a few dozen miles and their thorn-gashed hands, then to the official miracle of Guadalupe: the appearance of her image in a cloak full of fresh roses in the winter, and the unofficial one: those Castille roses weren't native to Mexico anyway; then he thinks of Mexico, the border, the INS, and his mother's kitchen, which has a bigger, handsomer image of this Virgin in it. His friend comes, guns the engine, and the black smoke of unburnt fuel comes out the tailpipe. Ahead of them the truckload of strawberries takes off in the opposite direction, and the fruit of their labor will end up in margaritas, in supermarkets, and even in the farmer's market in Boston, where only those who read the fine print will realize they aren't buying local produce.

This is the kind of story that is easy to recount in print, but it is seldom told in photographs anymore: because photographs exist in compositional genres, and even this small story keeps slipping out of genre, though its main one must be landscape—not only the landscape of the strawberry fields, but also of the oilfields which fuel the car, maybe homes, hospitals, borders, the metaphoric landscapes of the Virgin of Guadalupe's cloak of roses, and the supermarket's neat indoor hills of produce. About twenty-five miles down the coast from Watsonville is Carmel, where Edward Weston and his peers homed

in on its tidepools, rocks, and cypresses to refine their vision of a formalist photography of nature in which cameras would follow compositional genres rather than narrative continuities. A documentary photographer might have brought together the strawberries, the worker, the car, his home, as Walker Evans brought together still life, domestic interiors, portraits, and group portraits with images of the cotton fields to portray the lives of sharecroppers in Alabama. His work insisted that a comprehensive portrait move among these genres. But landscape photography is dominated now by the vision established in Carmel in which each image stands alone, and none refers to these narratives of production, interpretation, and history of place. In them, landscape has become a walled garden, separate from the world around it.

Photographs can be more complicated, however. One of Ansel Adams's most famous pictures appears in Edward Steichen's The Family of Man as *Mt. Williamson*. It portrays an arid field of boulders before a luminous mountain and is as neat an allegory as one could want of the universal truism about the rough road to the good. It is, of course, about something very specific extracted from Adams's social documentary work at the Japanese internment camp Manzanar (about a hundred and fifty miles due east of Watsonville) and is more properly titled *Mount Williamson, the Sierra Nevada, from Manzanar, California*, 1944. Though Adams made many pure, isolated landscape images, history and his followers have codified his work and developed the representation of landscape further. This practice parallels the national park system, which creates real walled gardens as subjects for this conceptual one: certain expanses of land set aside as islands of the natural for aesthetic experience. Formalist photography and the idea of a nature apart suit each other perfectly. Each draws meaning not from connections, which it frames often as contamination, but from segregation, a world sorted into categories. In the public imagination, out of these two sets of walls comes a third, marking off nature as a place for pleasure and leisure and epiphany, a place separate from the rest of experience. Procrustean categorizing has its uses. It lets things be contained, defined, controlled, and it allows mastery, but in a procrustean bed, the subject is always being stretched or hacked at to make it fit. Giving the subject rather than its frame priority means establishing instead flexible parameters and tolerating its unmasterable, amorphous sprawl.

Manzanar also appears in a photograph by Virginia Beahan and Laura McPhee taken half a century after Adams worked there. This time the camera has pulled back from the mountains to straggly apple

trees in the middle ground and sagebrush and rusty wreckage in the foreground. The sublime is here, but so is history, and so is agriculture. Beahan and McPhee's photographs straddle the divide between formalism and documentary, between narrative and composition, between the informational and the aesthetic. These photographers stick largely with landscape—with relatively natural space seen at middle or long distance, and a horizon for order—but they shoot along the line where the definitions blur and make photographs that don't respect the wall around the formal garden. They refuse the aesthetic languages of documentary, slipping its subjects into photographs that claim the beauties of formalism. Their images show us a world in metamorphosis, where categories melt and mutate, where subjects slip from genre to genre, where a new earth is being made out of fresh lava that buries houses and the old earth is being buried under construction of others. This is a world where natural sites become shrines, and shrines become works of art that represent the landscape; where stone is carved into both sculptures of bodies and homes for bodies; where water is sometimes holy and sometimes for irrigating crops; where sometimes nature and people serenade each other with their additions and emendations and sometimes threaten each other.

At the beginning of *No Ordinary Land*, we see the earth making itself. At the end we see it being harnessed and channeled to make the human infrastructures that insulate us from the elements. In between, the body's labor and the spirit's beliefs reshape it materially and conceptually. This is a pictorial account of the transformative nature of the world, in which categories cannot contain subjects as fluid as water and lava, and the answer to what anyplace is, is plural. Thus the boy in the foreground of an Icelandic body of water is playing, but in the background geothermal power is being produced. The landscape speaks of both leisure and labor, nature, culture and production, ancient forces and modern centralization, the chthonic and the technologic. These are landscapes that have been interpreted before the photographers got there to add their own layer of interpretations: Iceland has had its trees removed and its geothermal power harnessed, Costa Rica has become the site of miracles and butterfly farms, New Jersey has been paved, canalized, and set afire.

Need and imagination are at work everywhere in these landscapes. In some, natural phenomena become representations. Thus a Hawaiian eclipse becomes a painting of an eclipse at a flower show. The wild orchids of the rainforests become domestic flowers cultivated for social purposes—and though the eclipse is now a painting, the flowers are still real; that they are cultivated blurs the border between the made and the born, culture and nature. Hunting animals for food becomes hunting for sport, and practice for the sport involves target shooting, so the real animals are represented by lifesize plastic sculptures used as targets. The poet Marianne Moore wrote of "real toads in imaginary gardens." Here are molded panthers, deer and boars in a real garden, with a birdhouse in the distance to remind us that not all creatures are prey. The deer is brought into culture as meat or trophy. The wild bird, however, is given a humanlike home of its own. Both animals thus serve human purposes without ceasing to be wild. Real—and holy—water flows from under a mural of a maiden walking alongside a waterway in Costa Rica. Sometimes the natural world is offered up to the supernatural, as in the offering of flowers to a Buddha, but sometimes the gestures of devotion and the flowers are offered back to the earth, as with the blossoms on the volcano's lip in Hawaii. In these images, humans are not more powerful than nature, but they have very nearly equaled it. But when they have covered nature over or tamed it, they miss it and add images of it to their constructs, bringing the outside into the inside.

The photographs portray not the binary story of touched/untouched, but the subtle histories of kinds and layers of touches in the landscape, not an authoritative story but a plethora of divergent versions. Perhaps what is most outstanding about the images gathered here is their refusal to simplify. Almost every landscape seems to be a nexus, a place where multiple impulses, forces, and practices come together. Places that are damaged are still beautiful, as are working places, and the most conventionally beautiful kinds of landscapes— oceans, mountains—have signs of human presence pulling them back from the Otherness they often signify in photographs. The work insists on restarting a complex conversation about the ways our lives are intertwined with the spaces and substances of the earth, a conversation that seems to have its origins behind the camera, with two visions and voices rather than one shaping each image.

Working & Believing

A WOMAN STEPS OFF THE END OF A TRAIL INTO THE HIGH SIERRA and drops her pack, pulls her keys out, and gets into the truck in the parking lot at the end of the road, near the dam. The dam fills up Hetch-Hetchy Valley, the first valley north of Yosemite Valley. The battle to keep it undammed transformed a mountaineering club into the world's first environmental activist organization. They lost this battle, but they have gone on to fight many more wars. (Though the bottom half of this valley is now a lake created by a concrete dam, it is more serene than Yosemite with its colossal tourism infrastructure, if more profoundly physically altered.) She writes for the organization and bought her truck out of money they gave her for a book. Like most environmentalists and landscape lovers, she drives a lot, and she tries to think about where the trail ends and the road begins, tries to connect the poetry of wandering with the prose of fossil fuel consumption. When she gets home in a few hours she'll take a shower in water from this dam, in snowmelt pumped down to a city where it never snows. And the things she's been thinking about will make all the objects around her murmur: her shower speaks of mountains in winter, the heap of mail waiting for her of trees, pulp mills and printers. Her coffee speaks of the *fincas* in the tropical highlands, and the sound of cars all night is a sound gnawing at the Arctic Wildlife Refuge, which she's never seen but knows is part of the same story as her gas tank now. All murmur of the vast systems of production and consumption that begin and end in the landscape. In the middle of the city, these landscapes are still with her.

A Sri Lankan diptych by Beahan and McPhee speaks of this: a roomful of drying tea facing the green terraces of a tea plantation. The black tea forms a kind of landscape against the skylike white wall, and hovering in that flat heaven is, rather than a celestial body, a square blackboard full of tallies, tracking the transformation of the curvilinear slopes into the grid of manufactory and the abstraction of profits. But the open terraces of the tea farm are still there implicitly, in the leaves and in the imaginations that connect them to their source.

In the European tradition, there are three kinds of landscape painting: the pastoral, the georgic or agricultural, and the historical. The first is the painting of landscape as a refuge from history and the labor of making, as a retreat to cyclical time and the simple life described in Virgil's *Eclogues*; it finds a place in painting from Giorgione onward to the picnickers and contemplatives of nineteenth-century painting. Virgil's *Georgics*, his instructive poem of agricultural life, has its equivalent in images—illuminated books of hours, paintings by Breughel, Constable, Millet, Grant Wood, and social realist depictions of agricultural labor, sowing and harvesting. History painting gives lie to the pastoral, since sometimes history happens in a landscape—Hannibal crosses the Alps, Washington crosses the Delaware. In all three, the subject is ultimately human, just as it is in Judeo-Christian representations of visions and visitations in the landscape.

I have always thought of that peculiar American genre of the uninhabited scene as a kind of history painting in which history has not yet happened. In the earliest American landscape photographs, those of the United States Geological Survey (made by men fresh from the battles of the Civil War), a figure or figures in the foreground enter the scene, like actors at the beginning of a play. This promise of a history that has not yet begun has become the covenant between the American imagination and its territory: an expectation that landscape should be the great Other to humanity and history, a promise that there is a world outside the social (belief in virgin wilderness requires forgetting the pervasive presence of Native Americans, whose transformations of the landscape are often invisible to unaccustomed eyes). This representational tradition of virgin wilderness came to be central to the American celebration of nature as a place of spiritual uplift. With that the American landscape ceased to be a precursor to history and became something else: religious painting. It's a vision in which spirituality is opposed to utility, and its visionaries must thus see nature's spaces and creatures as utterly separate from work, resources, food, and history. It's what Emerson was talking about when he wrote, "The noblest ministry of nature is to stand as the apparition of God. It is the organ through which the universal spirit speaks to the individual, and strives to lead the individual back to it." This fantasy of nature without biology was refined further in John Muir's rebellion against the backbreaking labor of life on his father's farm. He insisted with Emerson that the sustenance we ought look to the natural world for is spiritual, and that the spiritual is apprehended only visually. This transcendental stroke blotted out the intermediary landscapes of production and our more visceral relationships with the earth.

This American devotion to the virgin landscape also comes out of Genesis. Americans are deeply attached to stories of the Fall, whether they locate paradise in a golden age of family structure or a prehistory of virgin wilderness, an unpeopled paradise. And this

vision of a natural world utterly apart—a world whose meaning comes, paradoxically, from its separateness—has come to be the dominant image of landscape. This is particularly so in popular photography, in that vast market made out of the codification of Ansel Adams's wilderness images as gospel truth—calendars, posters, cards, books—which, in turn, seems to confirm in the popular imagination the reality of this world apart. Actual recreation, meanwhile, most often appears as bitter irony, as people who seem to be, in Woody Allen's words, "two with the universe": Diane Arbus's nudists and everyone from Roger Minick's to Richard Misrach's tourists succeed the pastoral's pipers and lovers (except in product ads for four-wheel drives, Power Bars, kayaks and so forth). Agriculture is seldom a subject any more, perhaps because it is no longer as emblematic as, say, Millet's gleaners or perhaps because this working relationship is irrelevant to a cult of nature apart (except when portrayed in documentary photography as exploitation of people or land). Represented thus, landscape becomes a luxurious irrelevancy, a playground or a temple for those with the time and inclination; it is no wonder many dismiss environmentalism as elitism.

The environmental historian Richard White writes about nature and work in an essay titled after a logging-town bumper sticker: "Are You an Environmentalist or Do You Work for a Living?" He declares,

> Most people spend their lives in work, and long centuries of human labor have left indelible marks on the natural world. From pole to pole, herders, farmers, hunters, and industrial workers have deeply influenced the natural world, so virtually no place is without evidence of its alteration by human labor. Work that has changed nature has simultaneously produced much of our knowledge of nature. Humans have known nature by digging in the earth, planting seeds, and harvesting plants. They have known nature by feeling heat and cold, sweating as they went up hills, sinking into mud. They have known nature by shaping wood and stone, by living with animals, nurturing them, and killing them. . . . Most environmentalists disdain and distrust those who most obviously work in nature. Environmentalists have come to associate work—particularly heavy bodily labor, blue-collar work—with environmental degradation. . . . This distrust of work, particularly of hard physical labor, contributes to a larger tendency to define humans as being outside of nature and to frame environmental issues so that the choice seems to be between humans and nature.

This is another accomplishment of *No Ordinary Land*: portraying the landscapes of labor and inhabited landscapes not as scenes of a fall from grace, but something much more ambiguous. Nature is not a victim in this book, nor a virgin, and work is not a villain. The sites we see are not the clearcuts that have become the environmental trope for work in nature, but sites that are often harmonious, often ancient: the irrigation ways and tea slopes of Sri Lanka, fruit orchards, flower farms, old salt wells, as well as slash-and-burn agriculture in the tropics, and power plants in the north. There is no before and after in this work, neither the apocalypse of ecocide nor nostalgia for archaic practices and unpeopled paradises, only a long, complex during. And time itself becomes the subject in one of the most complex diptychs here, that of the Chumash cave in Santa Barbara and the Sri Lankan mosque. The cave is painted with wheel-like celestial bodies that suggest a map or chart, since most traditional people carefully charted the movements of sun, moon, and stars to measure time. And with this comes a reminder that even modern units of time, days and years, are still measurements of the motion of the spheres; the mosque's clocks, which indicate times for prayer, speak of a time that is ultimately the time of the earth's daily rotation. Disembodied time is a measure of objects' motions in space. And with this hint, that even the most transcendent and abstruse religion with its modern materials and inscriptions is tied back to the earth, the artists remind us that just as no landscape is out of reach of the human, so no human activity or space is out of reach of these landscapes. All of it is linked.

Note: The first anecdote describes a generic worker in the strawberry fields of Watsonville, now a political hot spot where unions and environmentalists have been addressing the rights of farmworkers and the dangers of methyl bromide, a deadly, ozone-depleting toxin used to sterilize the soil of strawberry fields. A huge portion of the strawberries consumed in the US come from this central California location, and I saw Watsonville strawberries in the Boston farmer's market myself in June of 1997. The Virgin of Guadalupe appeared to the Mexican Indian Juan Diego on December 9, 1531, and afterwards; when the bishop of the area wouldn't believe that he had seen her on a nearby hillside, Juan picked roses at her behest, filled his cloak with these out of season blooms and returned. The roses themselves convinced the Bishop, and when the cloak was emptied the image of the Virgin of Guadalupe had miraculously appeared on the inside of the cloak, which is still vividly colored and on display in its church in Mexico.

The second anecdote describes me, as readers will no doubt have noticed, on an excursion a few years ago. Estelle Jussim and Elizabeth Lindquist-Cock's book *Landscape as a Photograph* (New Haven: Yale University Press, 1985) first called my attention to the decontextualization of Ansel Adams's Manzanar mountainscape (which was marvelously recontextualized by *Unspoken*, 1994, an installation by Kim Yasuda at the Friends of Photography). And Richard White's superb essay "Are You an Environmentalist or Do You Work for a Living?" appears in *Uncommon Ground: Rethinking the Human Place in Nature*, edited by William Cronon (New York: Norton, 1996); the passage quoted appears on p. 172.

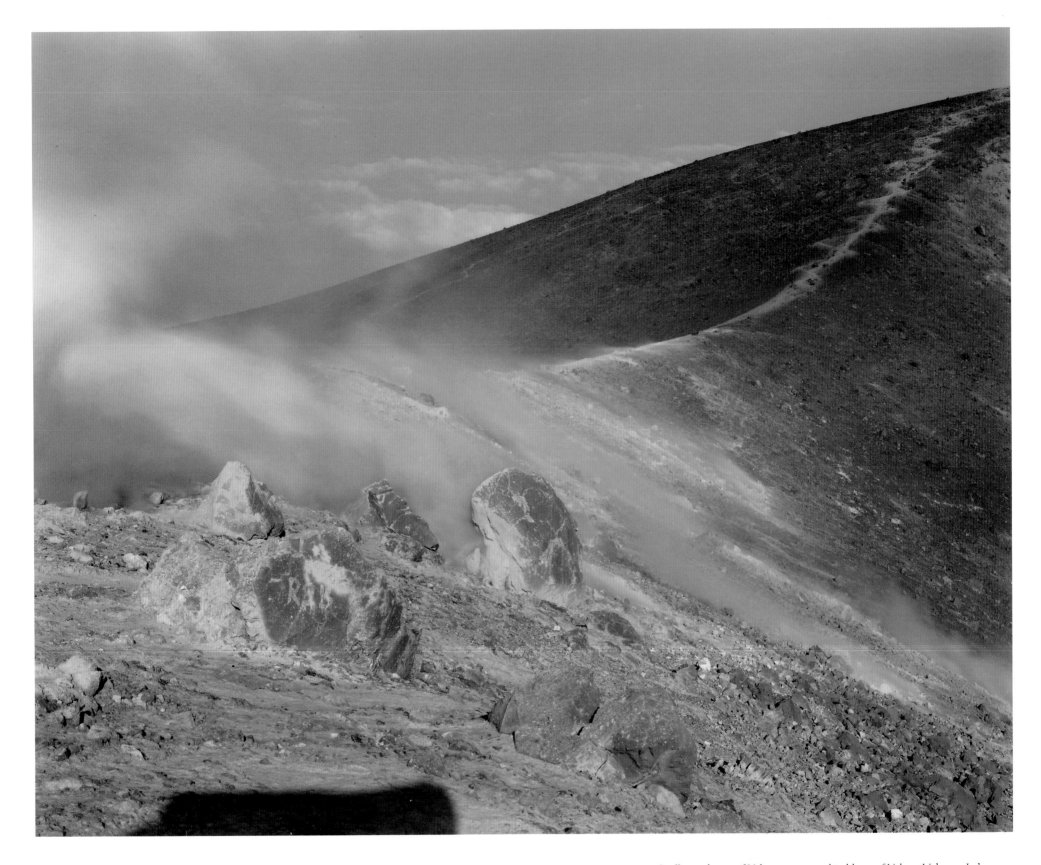

Graffiti on the rim of Vulcano crater, mythical home of Vulcan, Vulcano, Italy, 1994

In Search of
NATURE

The natural world of the Taoist is never truly wild: the human figure is always somewhere—travelers on a mountain path, the scholar-hermit in his cottage, and neat rice plots.

—YI-FU TUAN, *Passing Strange & Wonderful*

Some speak of a return to nature. I wonder where they could have been.

—FREDERICK SOMMER, *Aperture* 10:4

Ring Road as it passes between the Black Sand Desert and the glacier-covered volcano Katla, Mýrdalssandur, Iceland, 1987

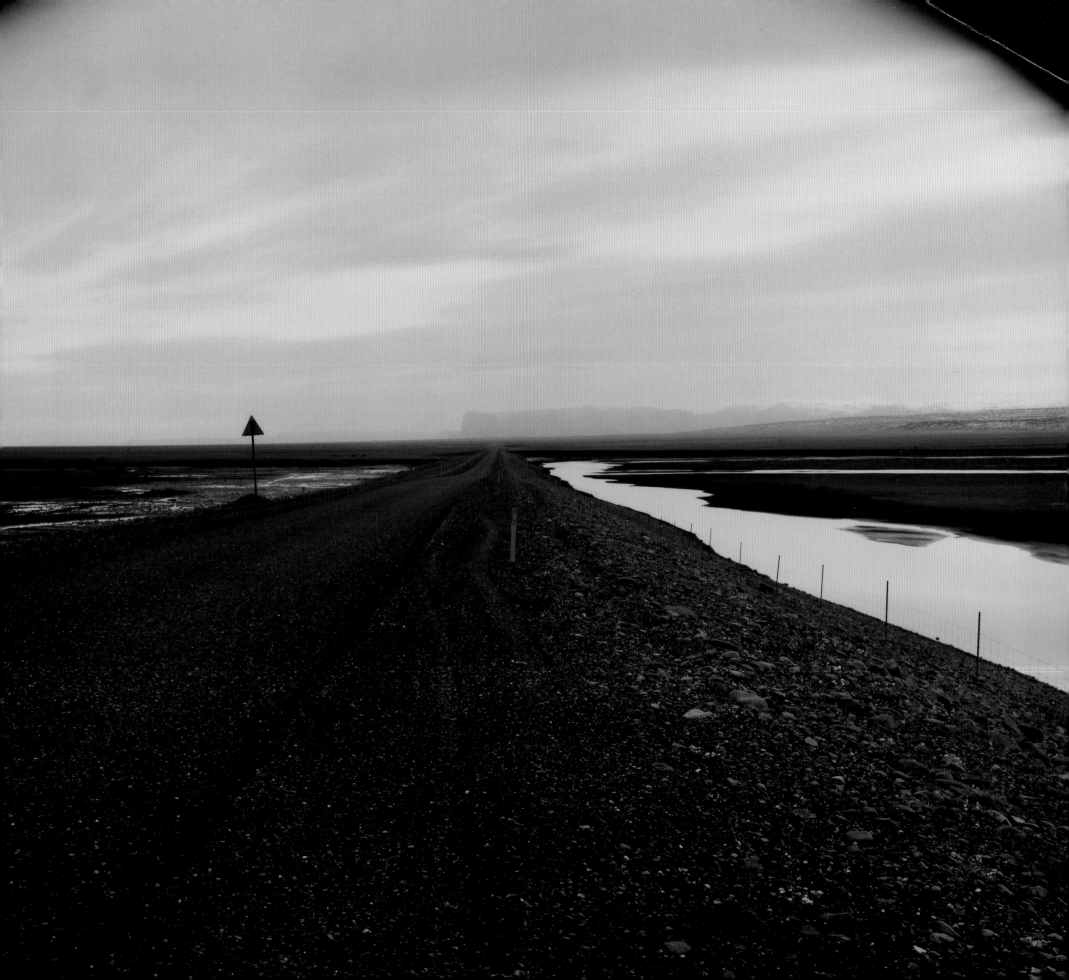

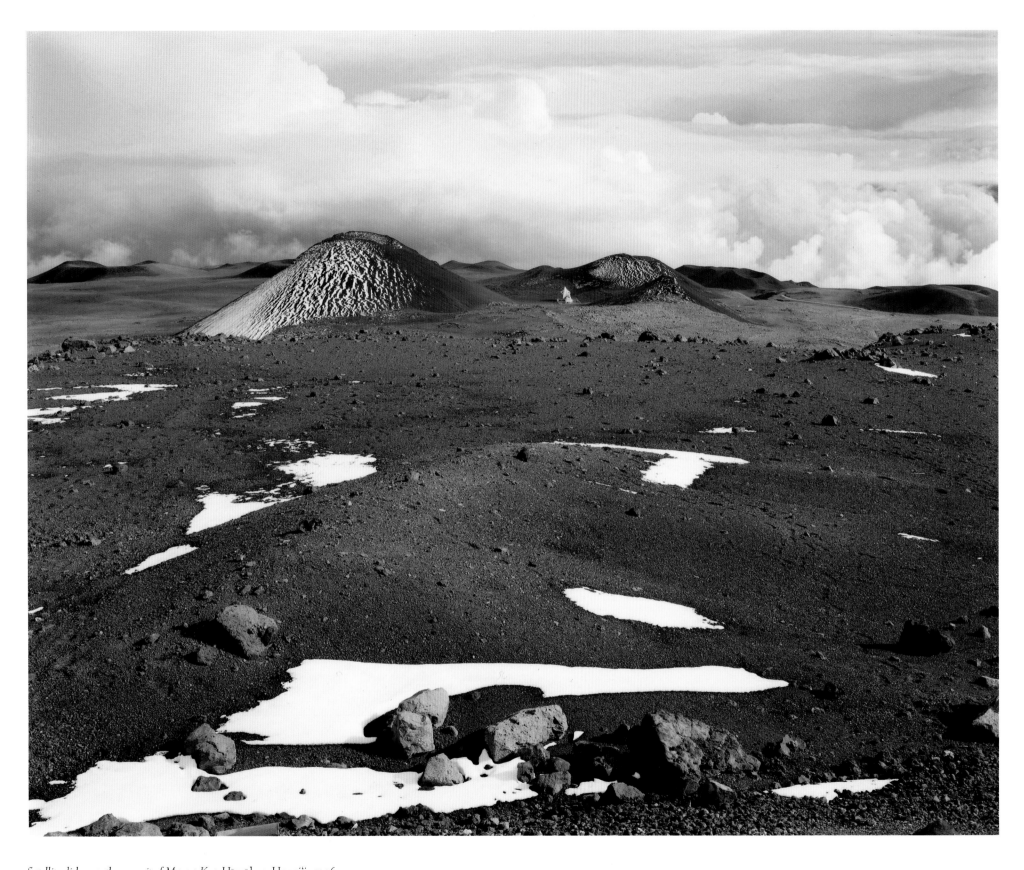

Satellite dish near the summit of Mauna Kea, Hāmākua, Hawaiʻi, 1996

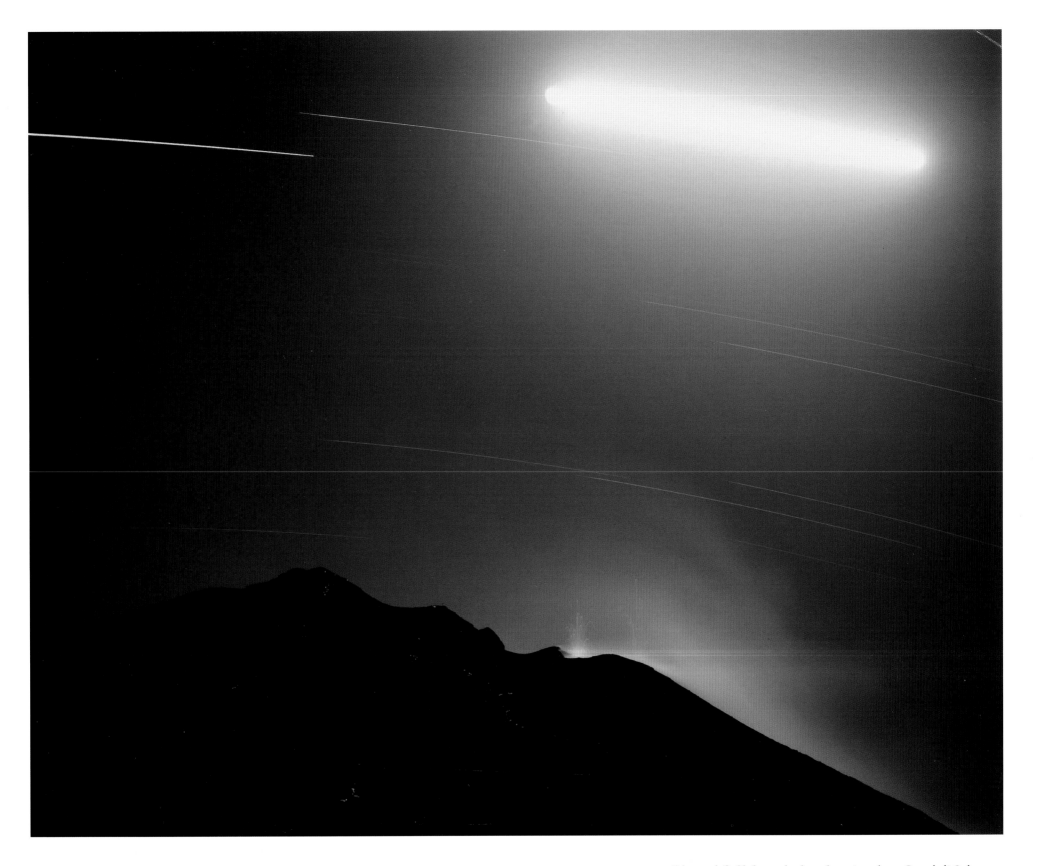

Hikers with flashlights on the slope of erupting volcano, Stromboli, Italy, 1994

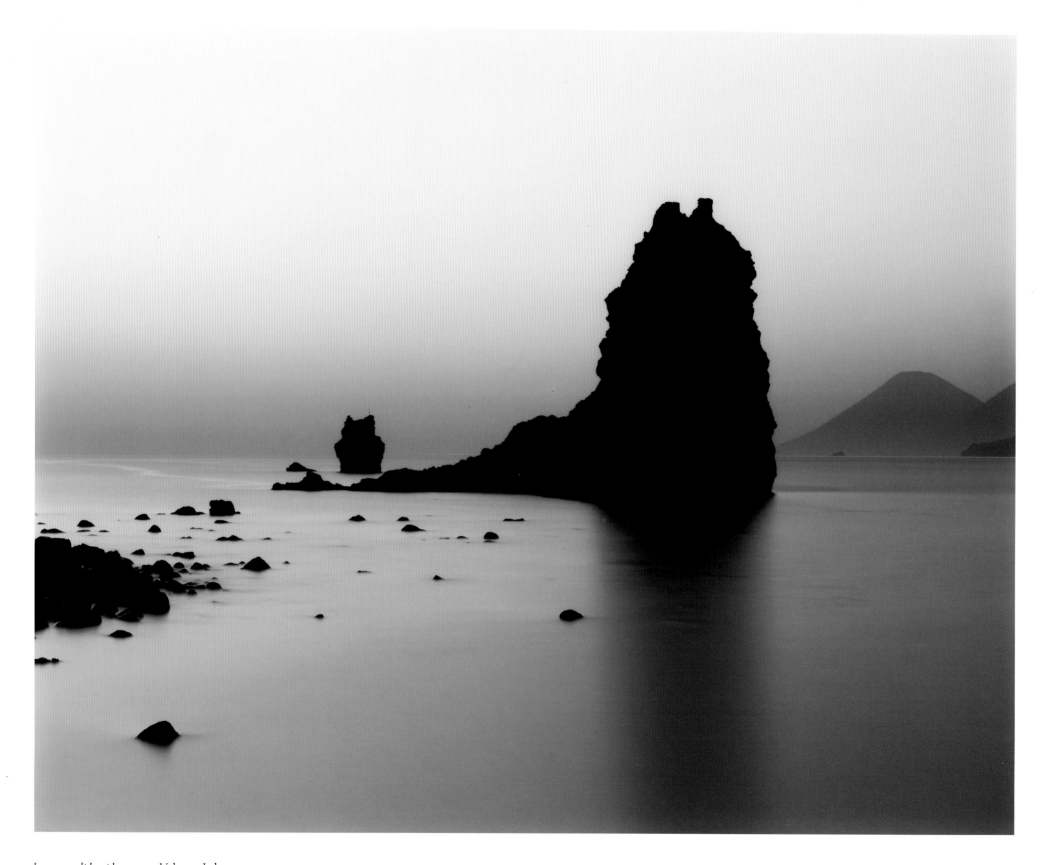

Lava monolith with antenna, Vulcano, Italy, 1994

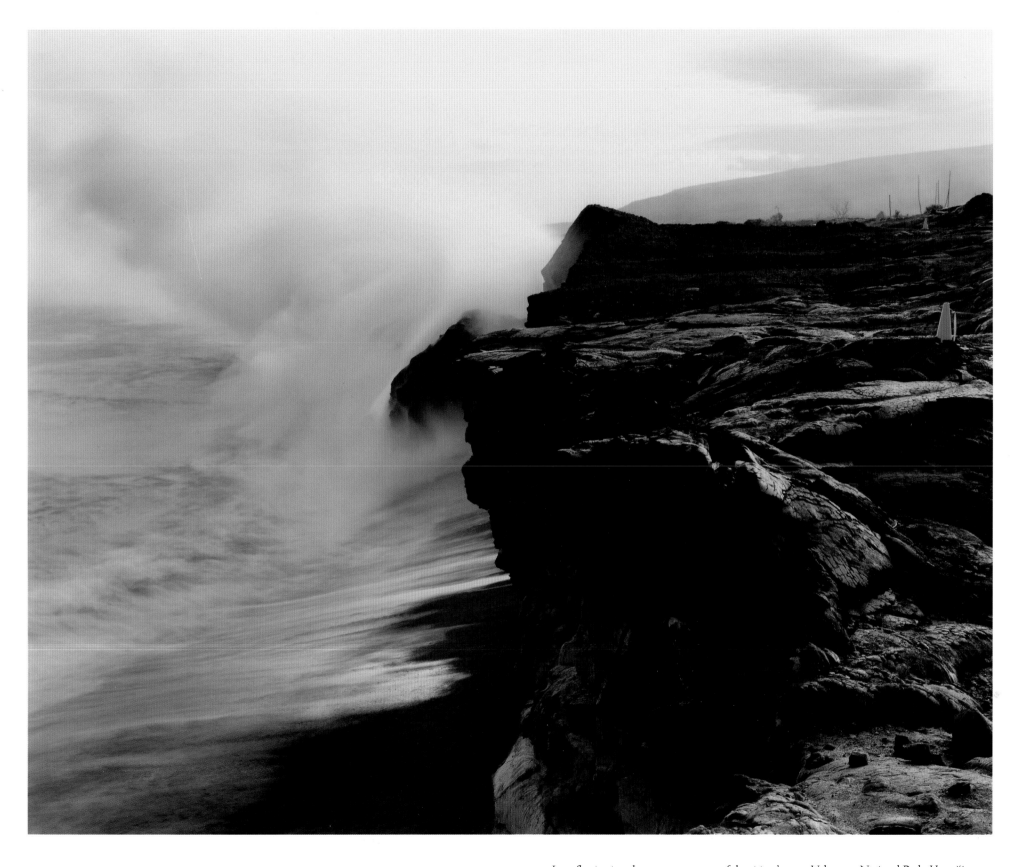

Lava flowing into the sea past remnants of the visitors' center, Volcanoes National Park, Hawai'i, 1991

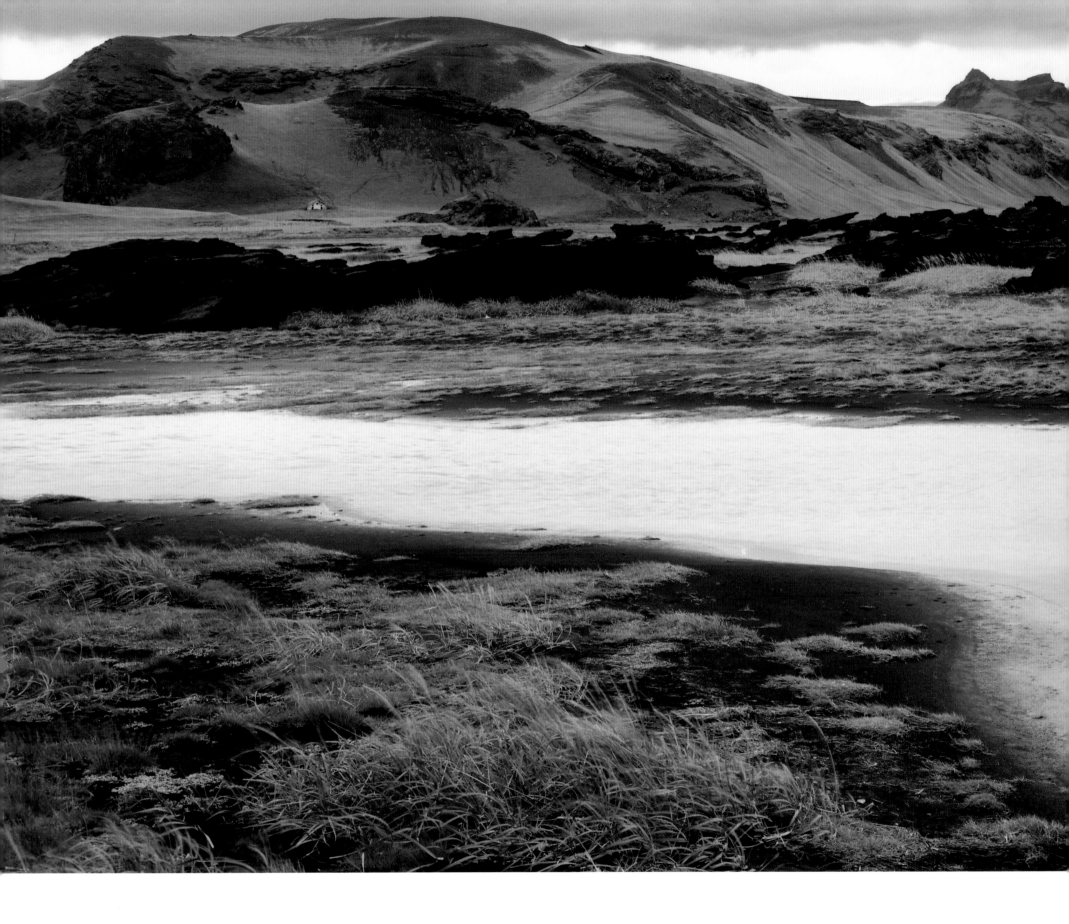

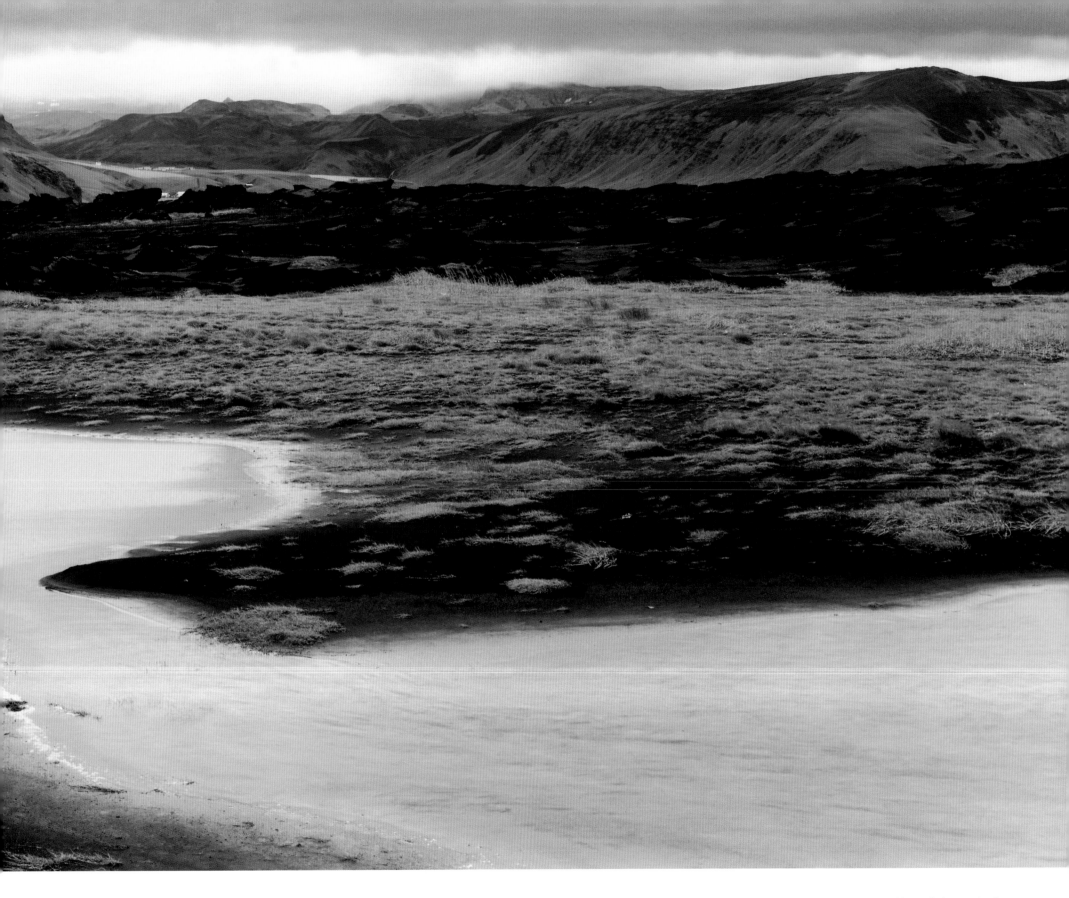

Lava fields, Dyrhólaey, Iceland, 1988

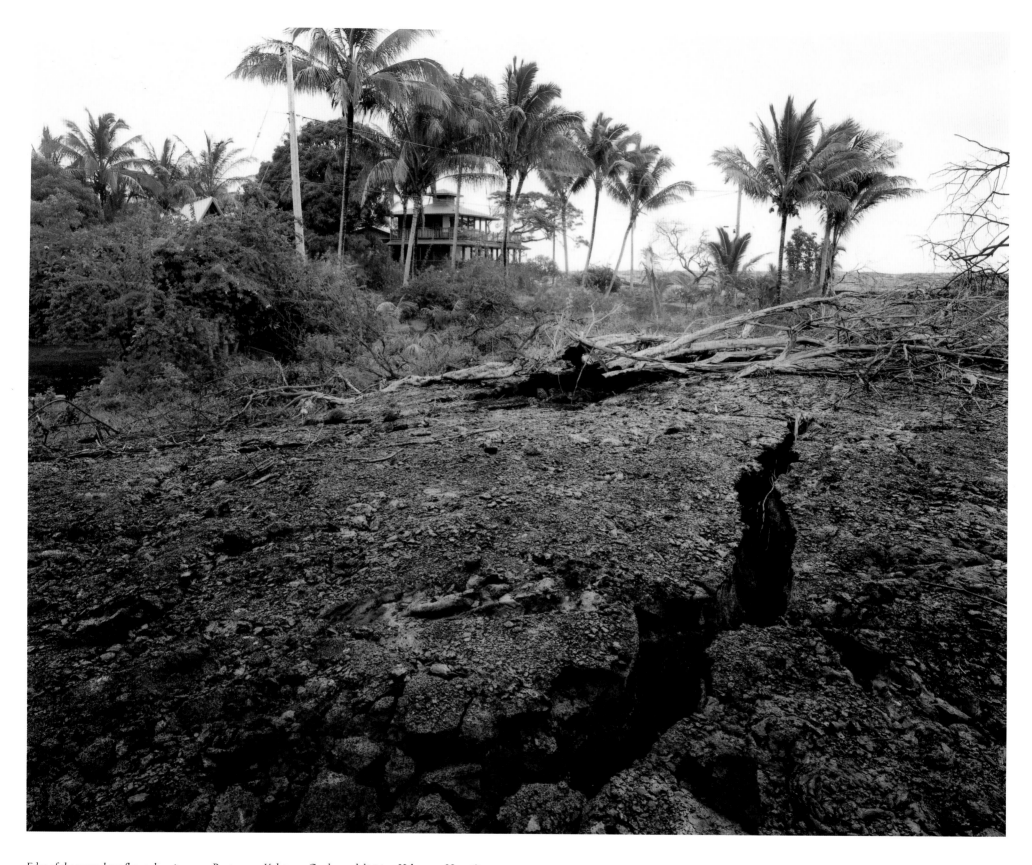

Edge of the 1990 lava flow where it crosses Route 130, Kalapana Gardens subdivision, Kalapana, Hawai'i, 1991

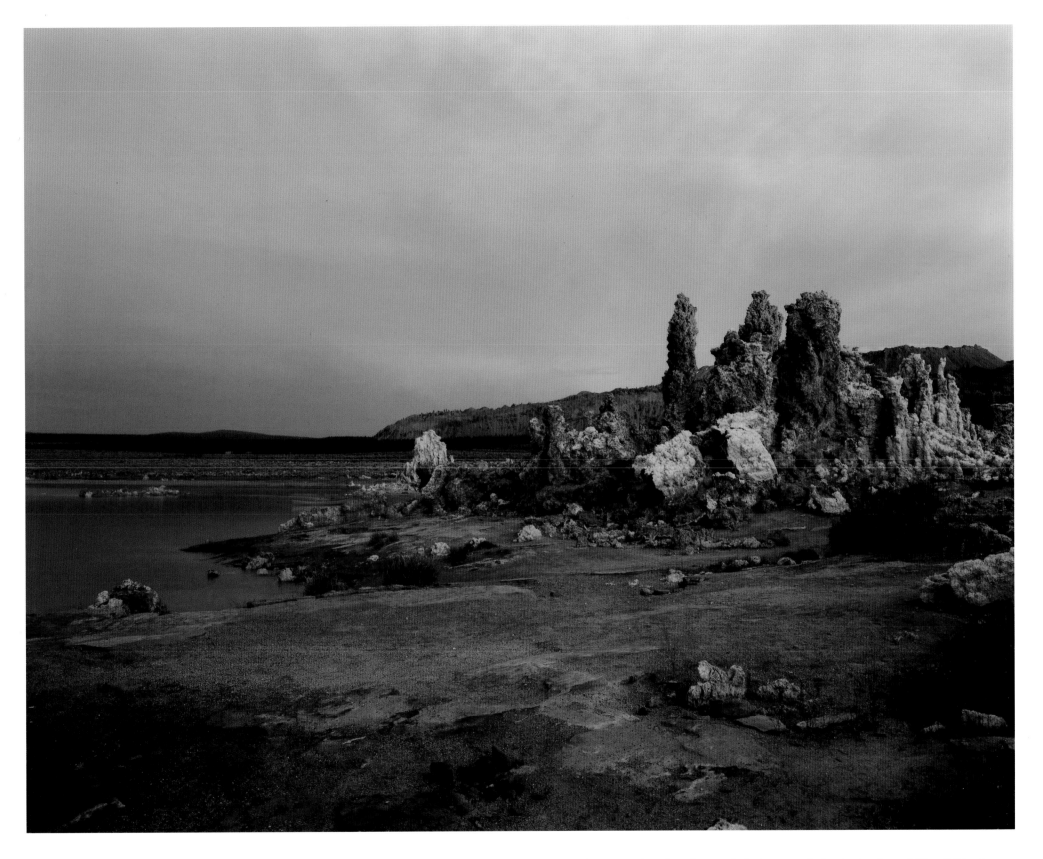

Tufa exposed as Mono Lake is drained to provide drinking water for Los Angeles, Owens Valley, California, 1995

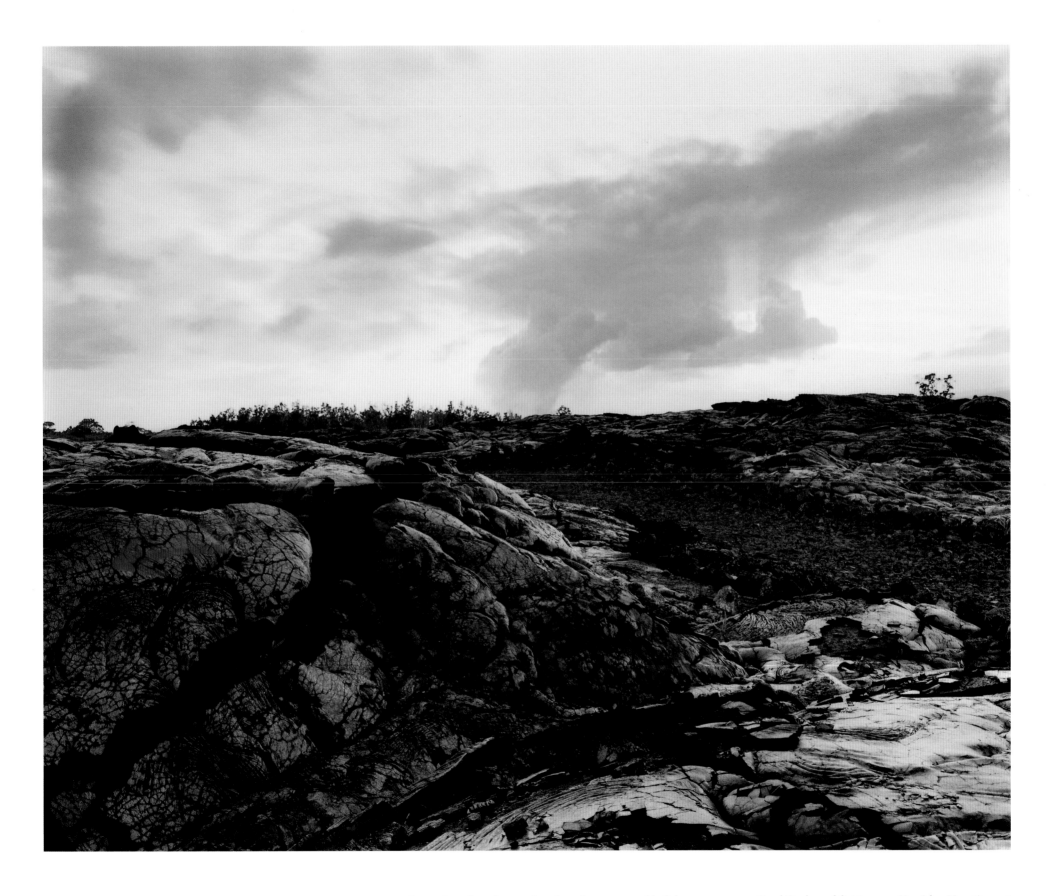

Surveyor's mark on the 1990 lava flow along a new road built by property owners, Royal Gardens subdivision, near Kapaʻahu, Hawaiʻi, 1996

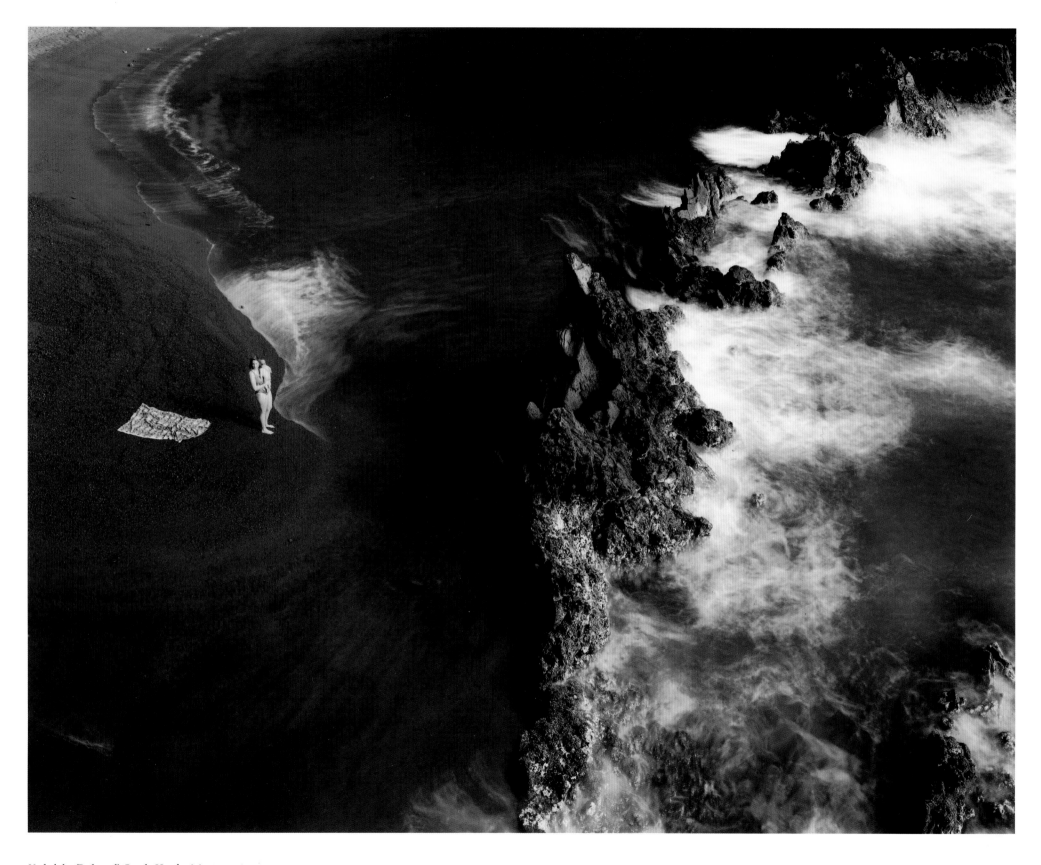

Kaihalulu (Red sand) Beach, Kauiki, Maui, 1996

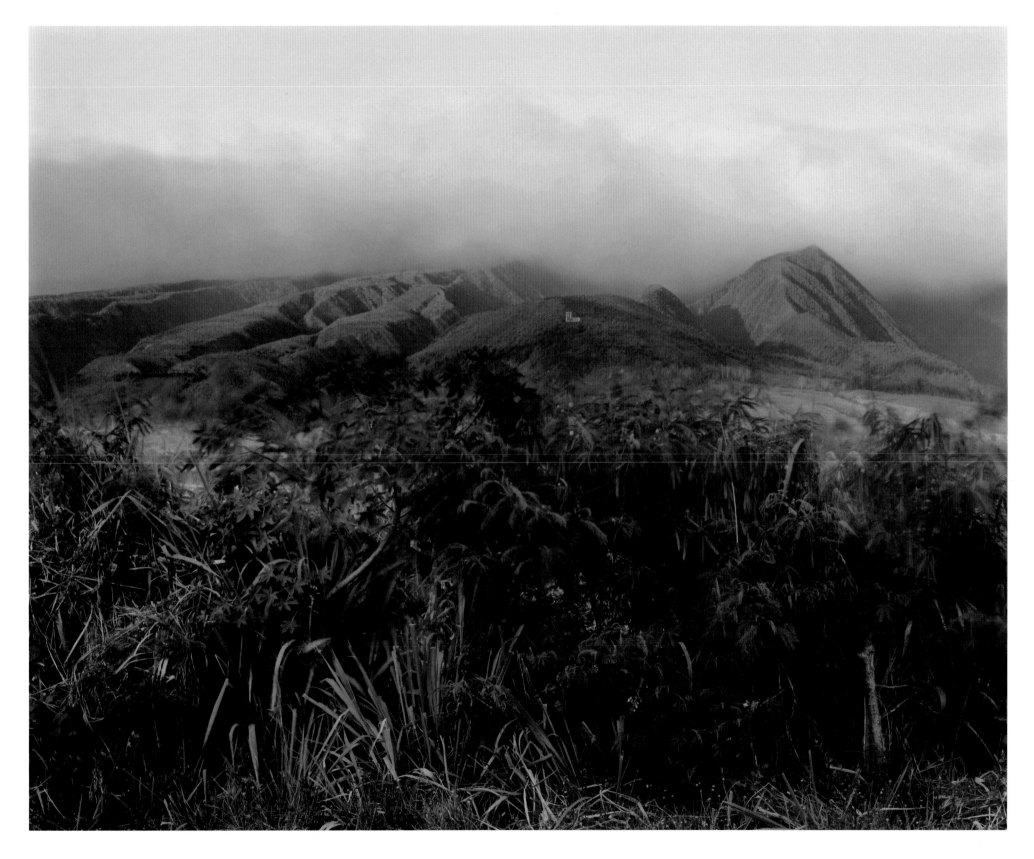

Symbol for the local team, Lahaina, Maui, 1991

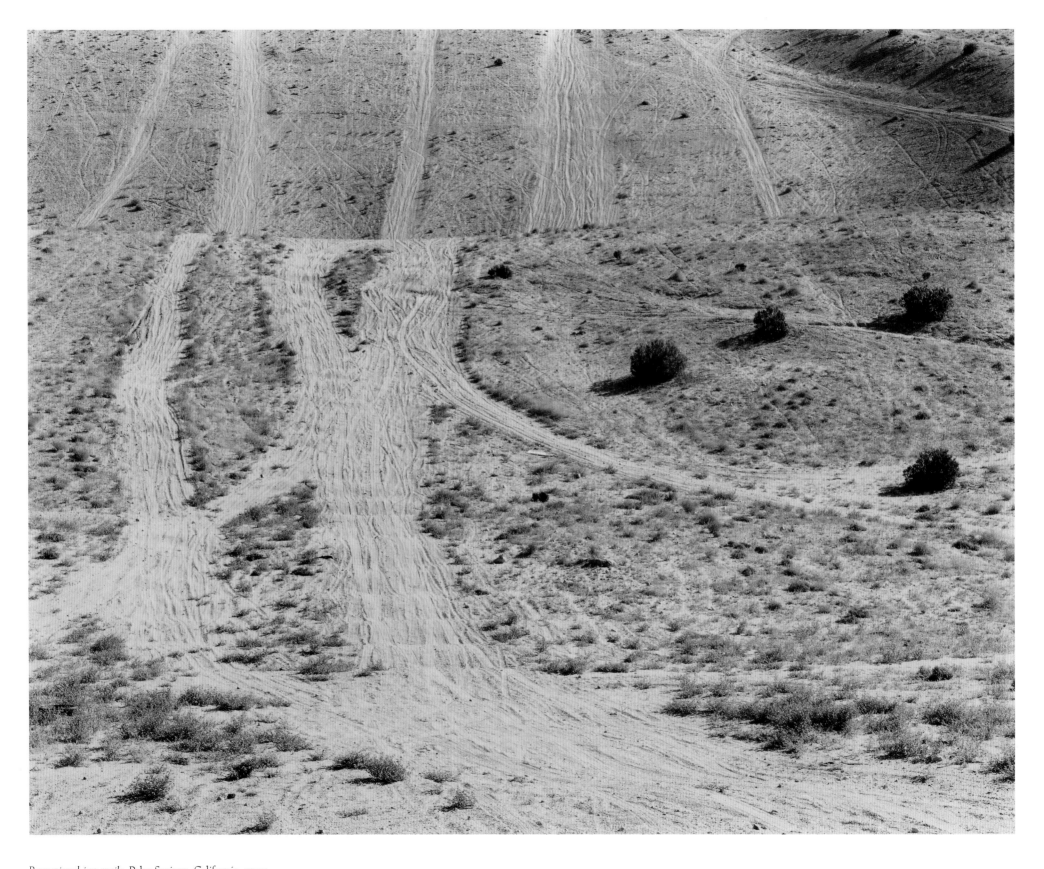

Recreational jeep trails, Palm Springs, California, 1995

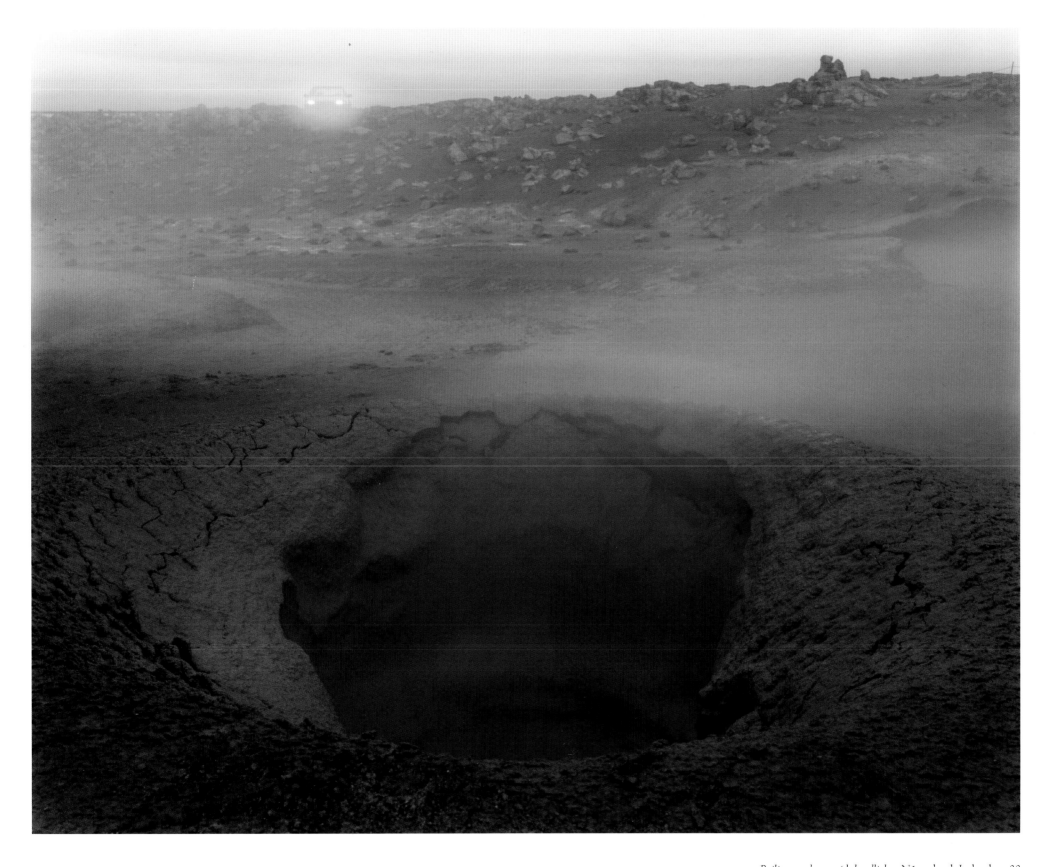

Boiling mud pot with headlights, Námaskard, Iceland, 1988

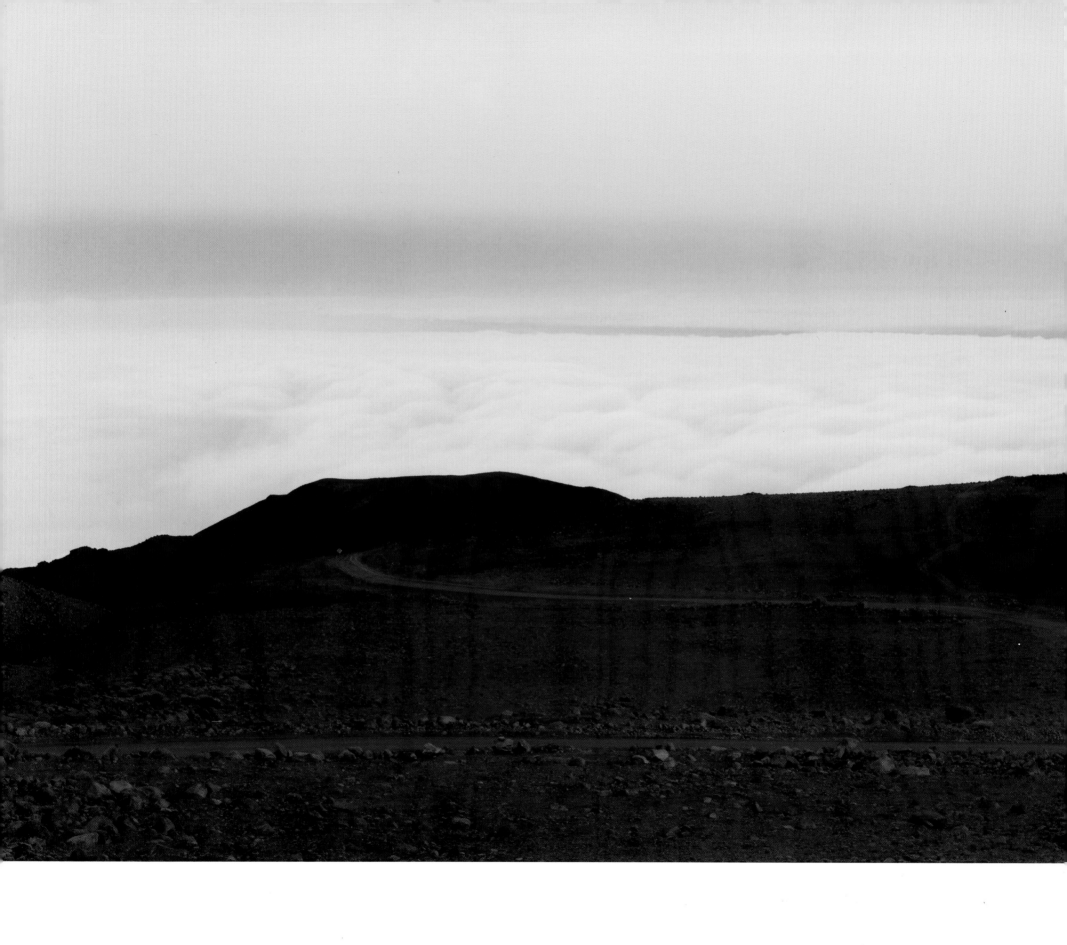

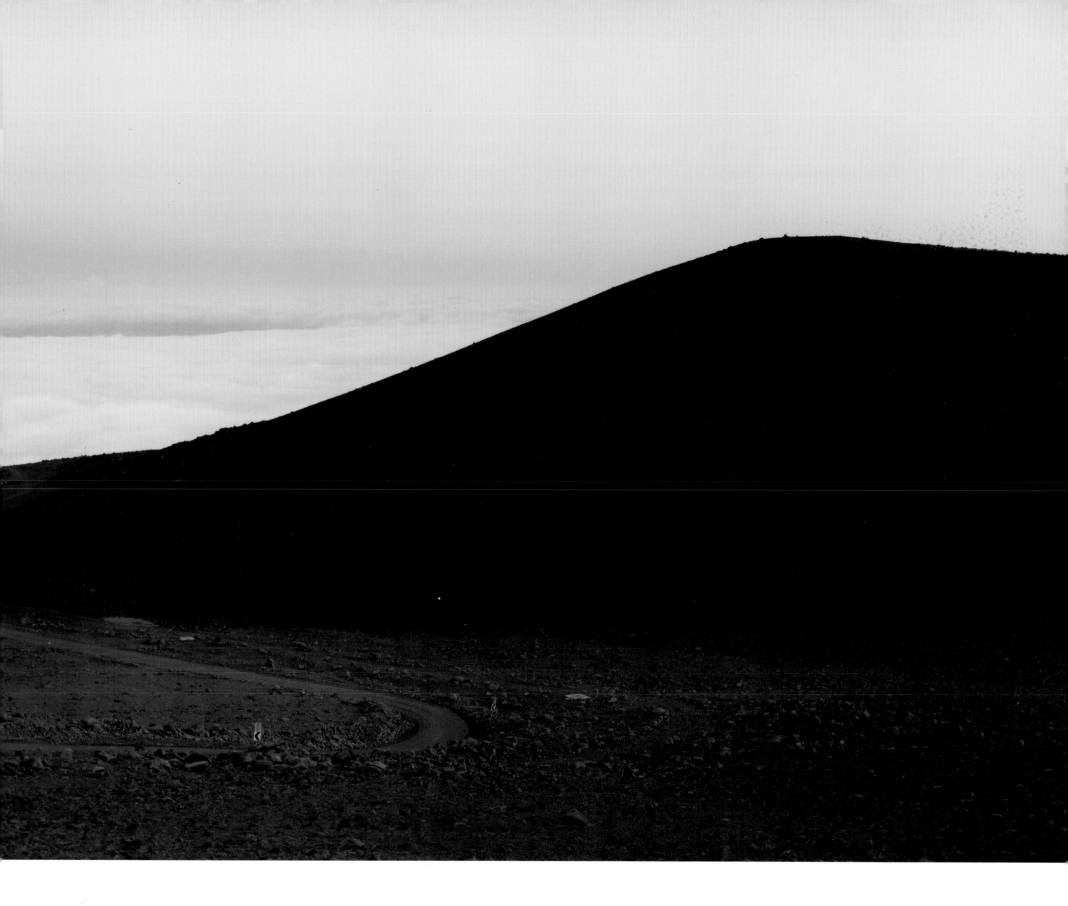

Road to the observatories on Mauna Kea, Hāmākua, Hawai'i, 1990

Spirits in the
LANDSCAPE

For although we are accustomed to separate nature and human perception into two realms, they are, in fact, indivisible. Before it can even be a response for the senses, landscape is the work of the mind. Its scenery is built up as much from the strata of memory as from layers of rock.

—SIMON SCHAMA, *Landscape and Memory*

Land is also time. The greening of time is a clock whose hands are blades of grass moving vertically, up through the fringe of numbers, spreading across the middle of the face, sinking again as the sun moves from one horizon to the other.

—GRETEL EHRLICH

Foundation of a burned house in Carbon Canyon, Santa Monica Mountains, California, 1995

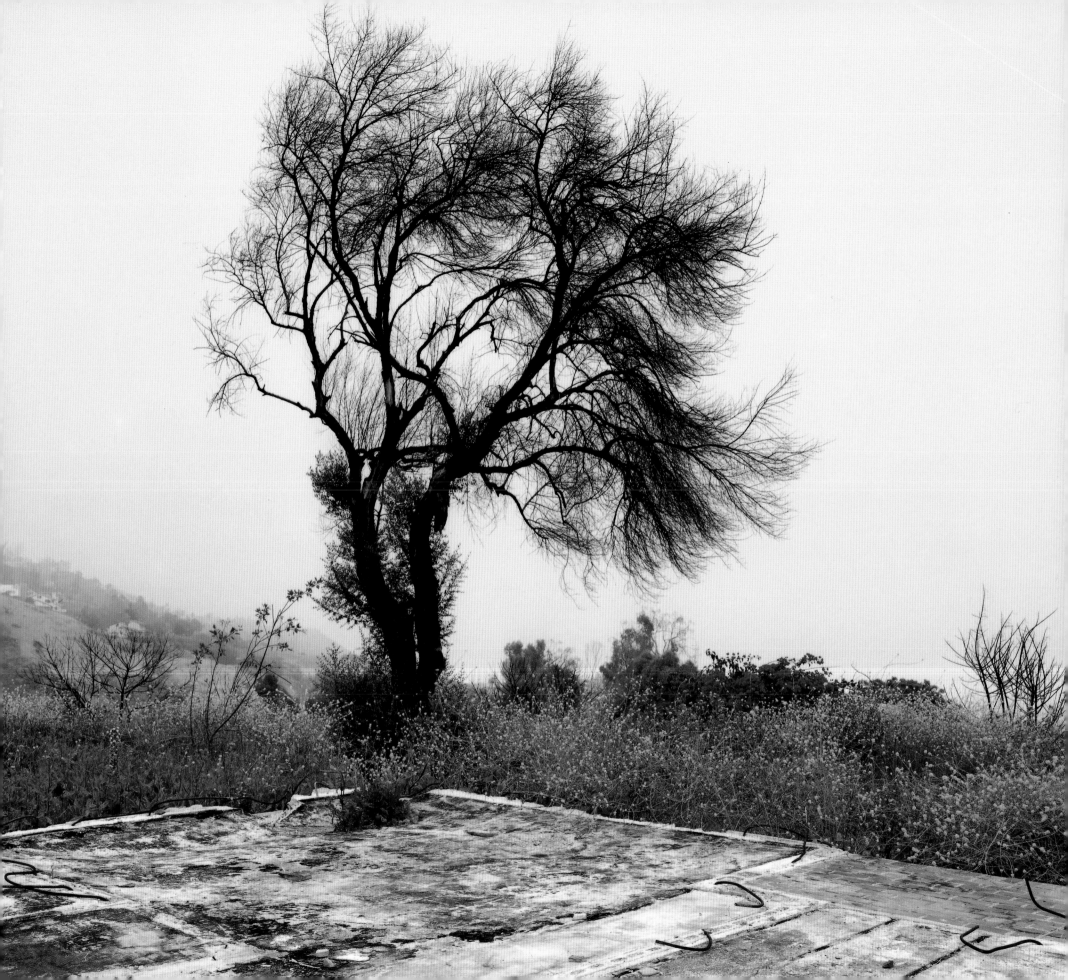

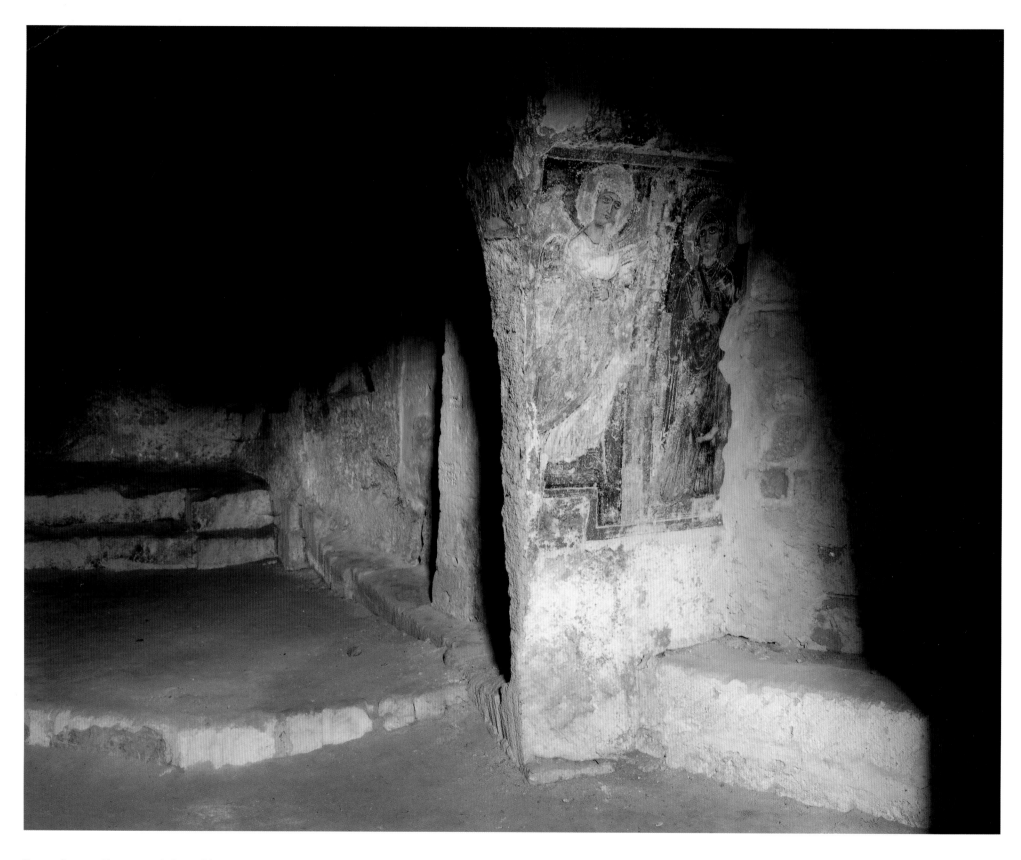

Fourteenth-century Byzantine-style fresco of the Annunciation, Cave Church of San Giovanni in Monterrone, Matera, Italy, 1994

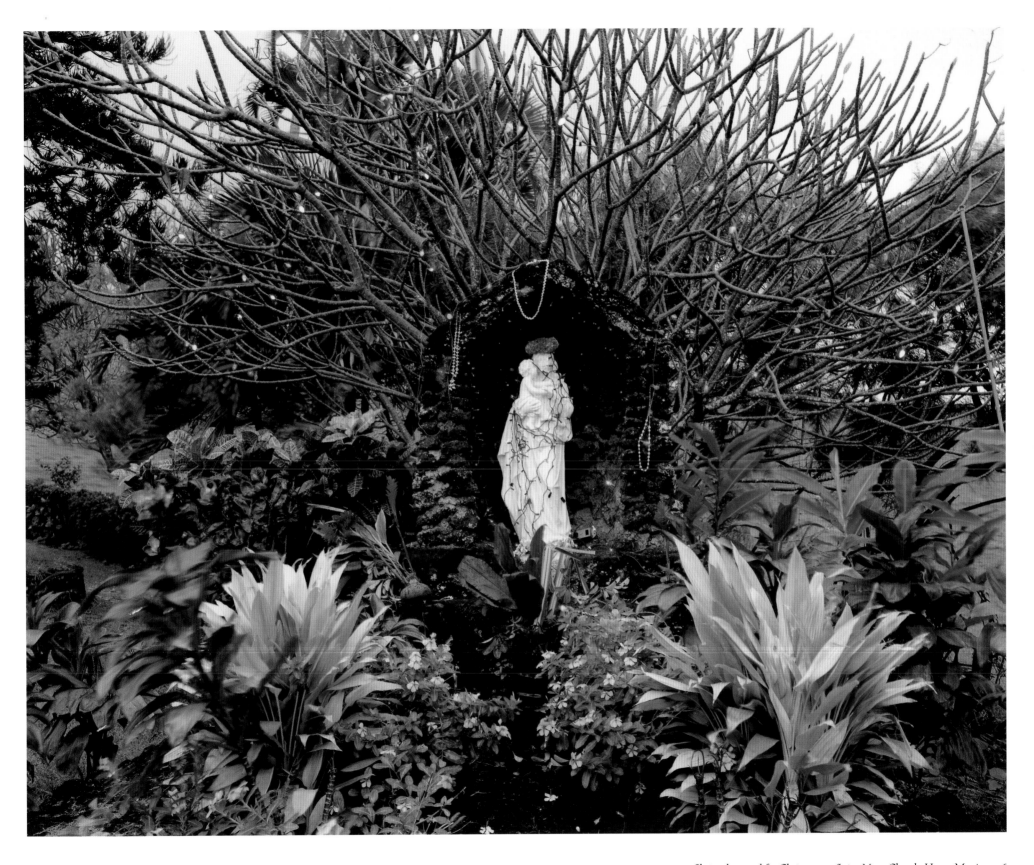

Shrine decorated for Christmas at Saint Mary Church, Hāna, Maui, 1996

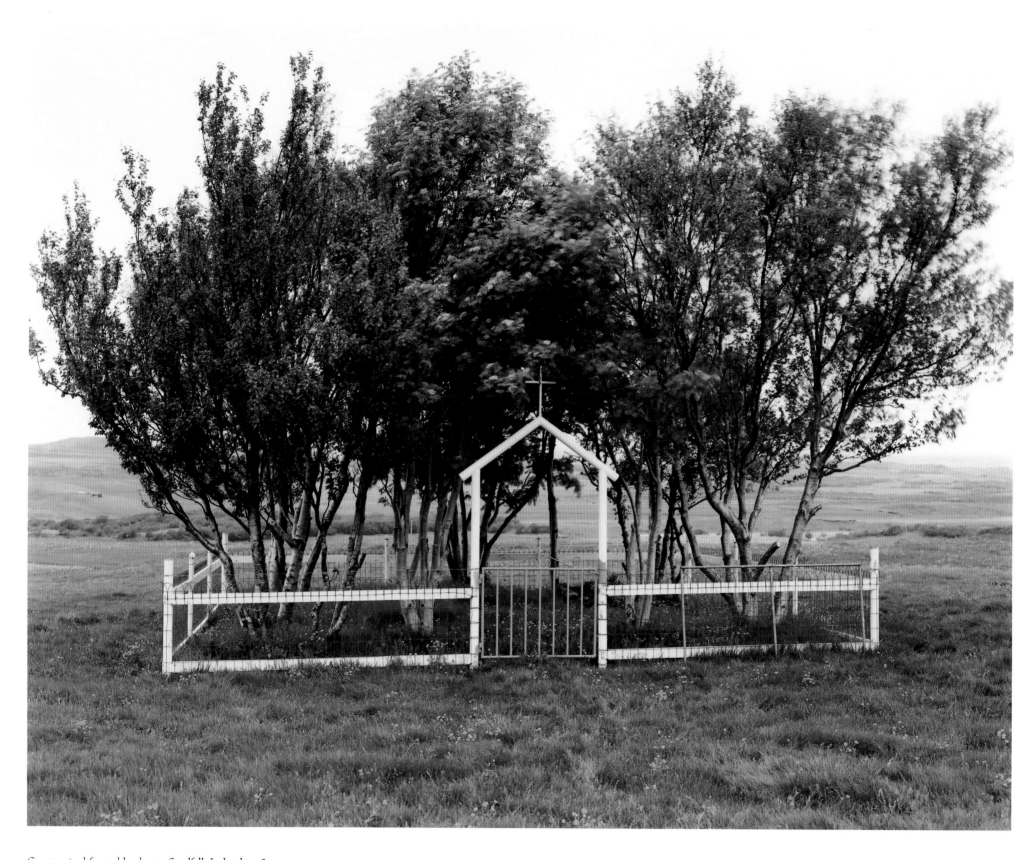

Cemetery in deforested landscape, Sandfell, Iceland, 1987

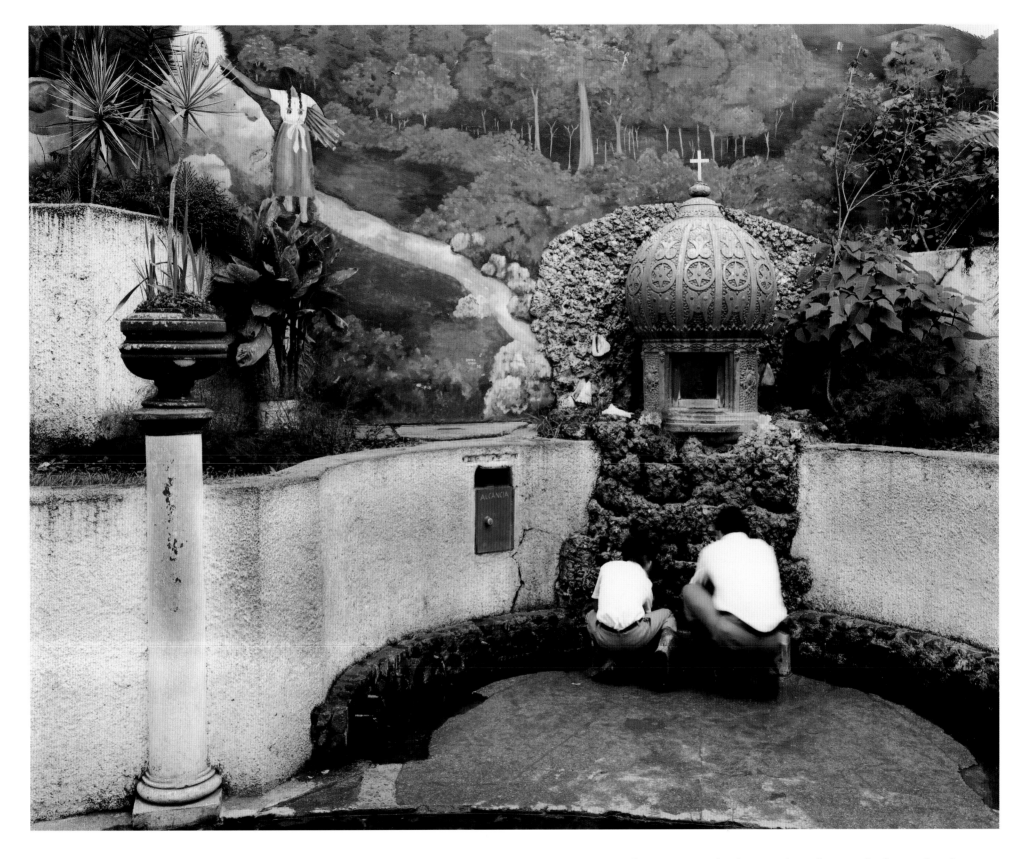

Mural depicting the 1635 discovery of a statue of La Negrita, Costa Rica's patron saint, Basílica de Nuestra Señora de Los Angeles, Cartago, Costa Rica, 1992

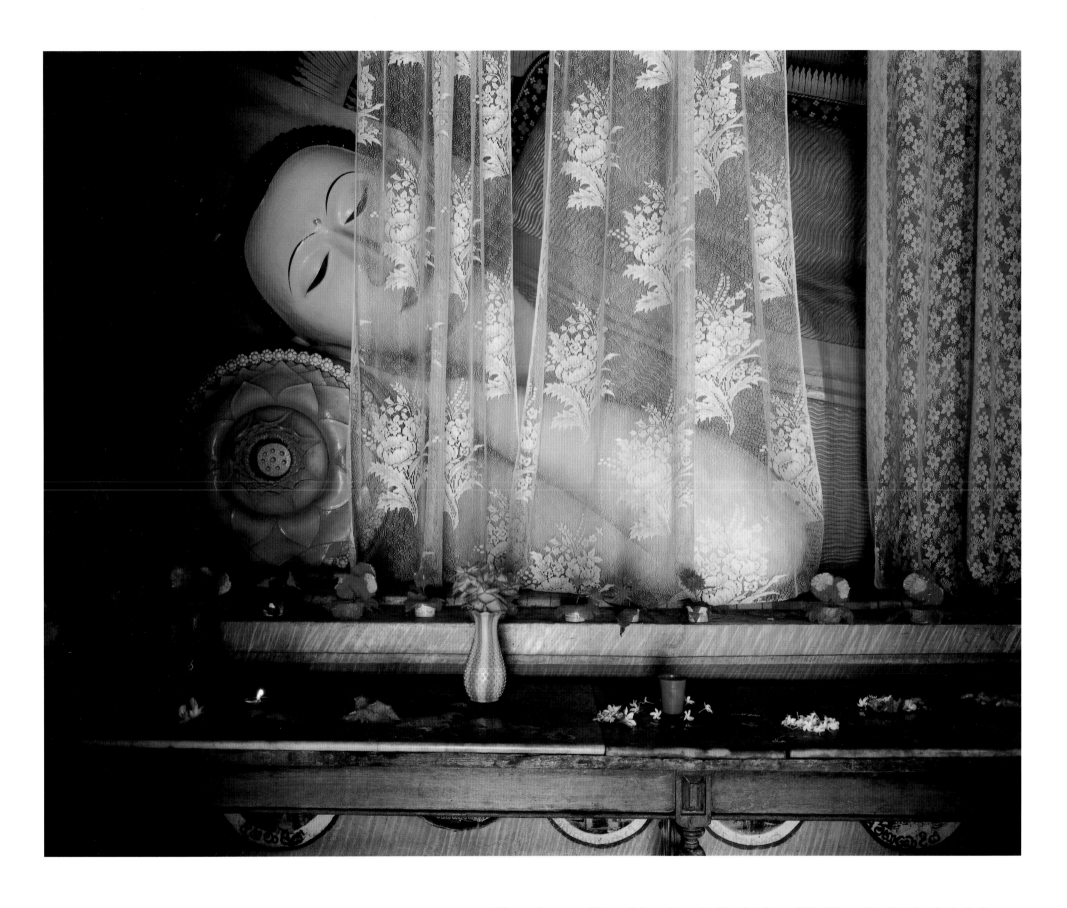

Offerings of jasmine and hibiscus before a sleeping Buddha, Subodhrama Maha Viharaya Temple, Dehiwala, Sri Lanka, 1993

Ceiling with illustrations painted from black-and-white photographs of Sri Lanka's dagobas, Gangarama Temple, Colombo, Sri Lanka, 1993

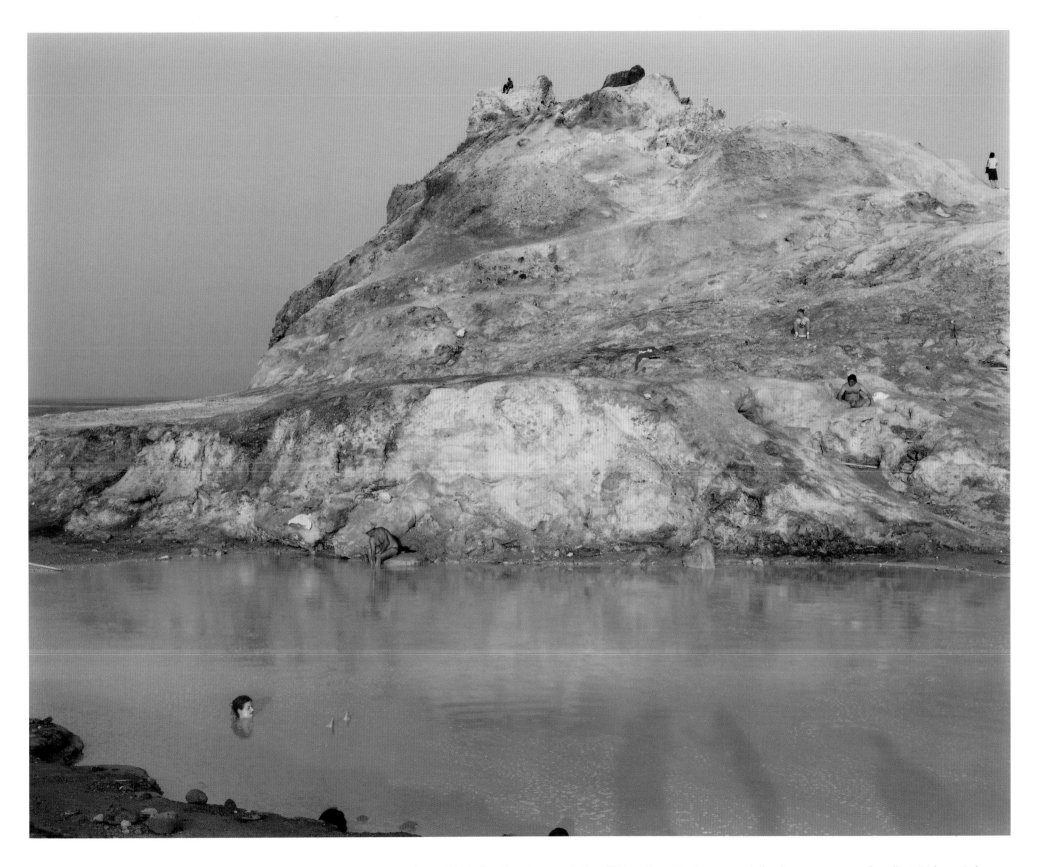

Healing mud baths formed in 183 BC at the foot of Vulcanello, medieval entrance to hell and a tourist attraction for millenia, Vulcano, Italy, 1993

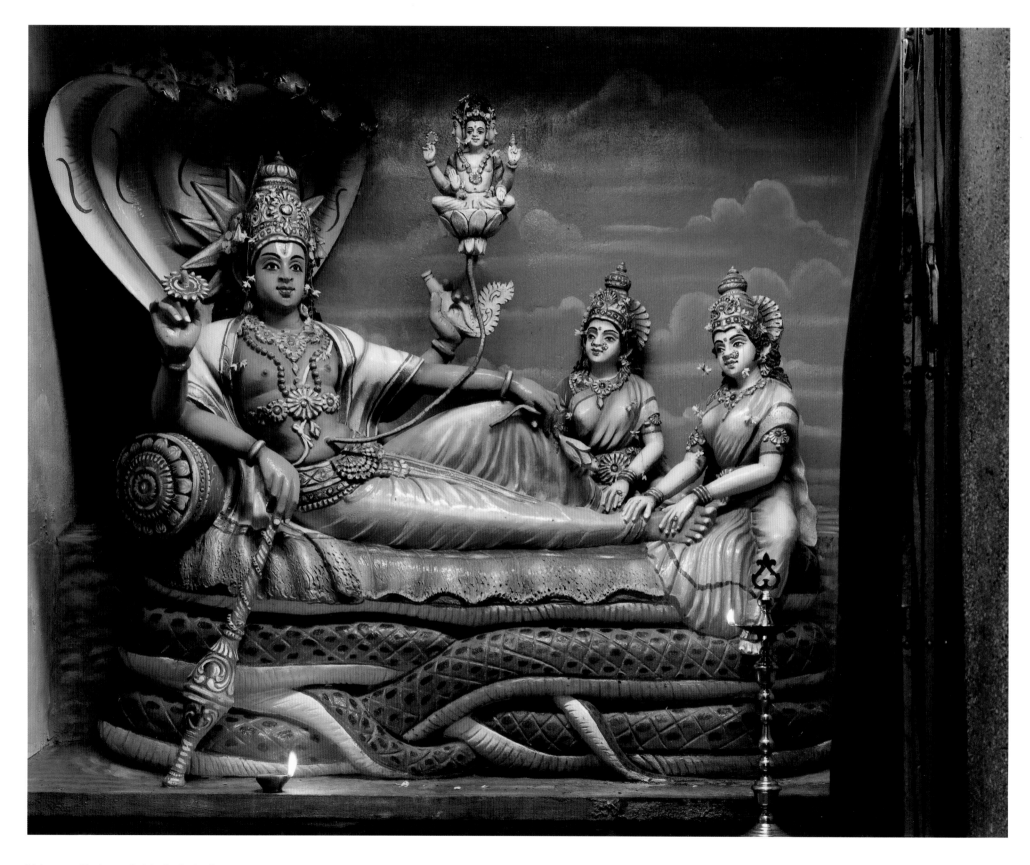

Vishnu in a Hindu temple, Matale, Sri Lanka, 1993

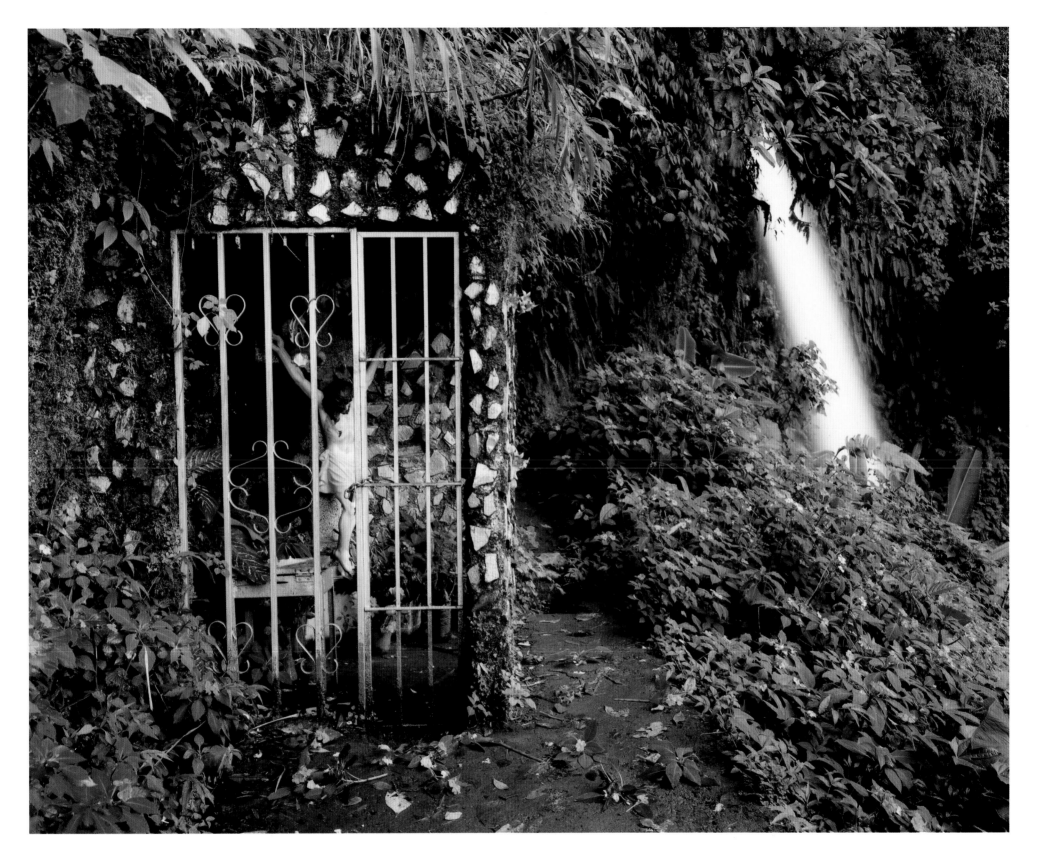

Shrine at La Páz waterfall, Vara Blanca, Costa Rica, 1992

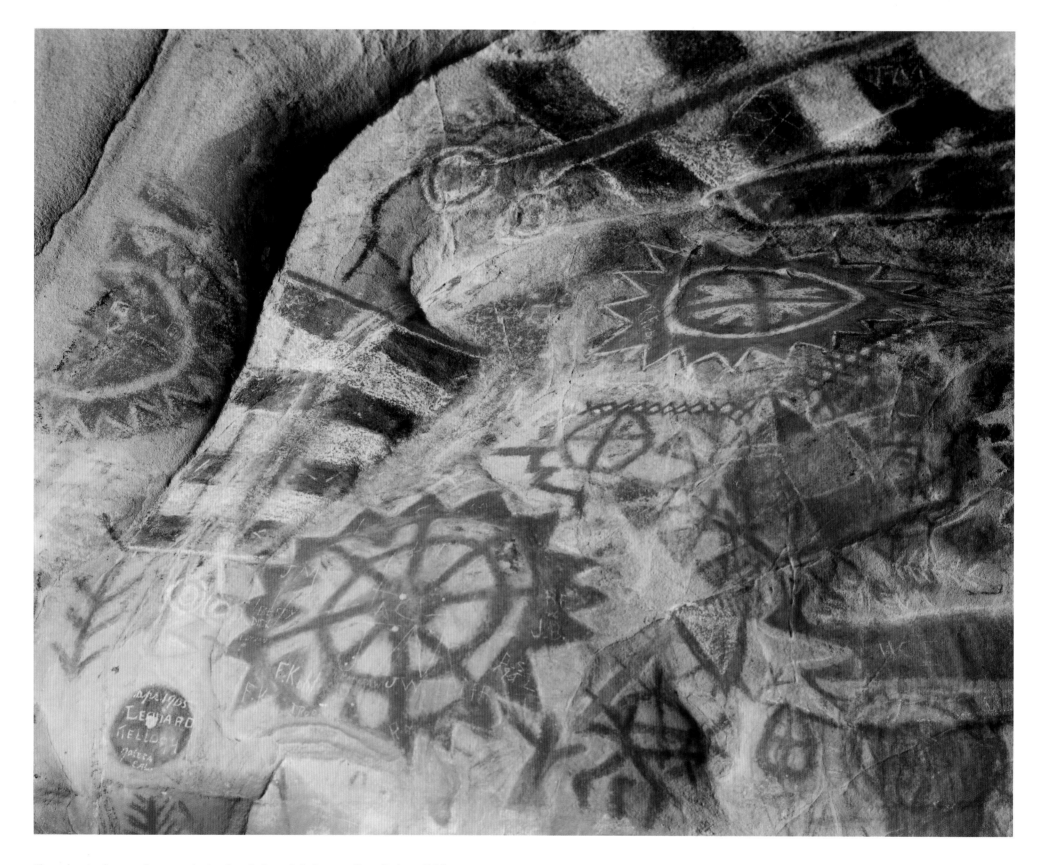

Chumash painted cave with pictographs thought to be heavenly bodies, near Santa Barbara, California, 1995

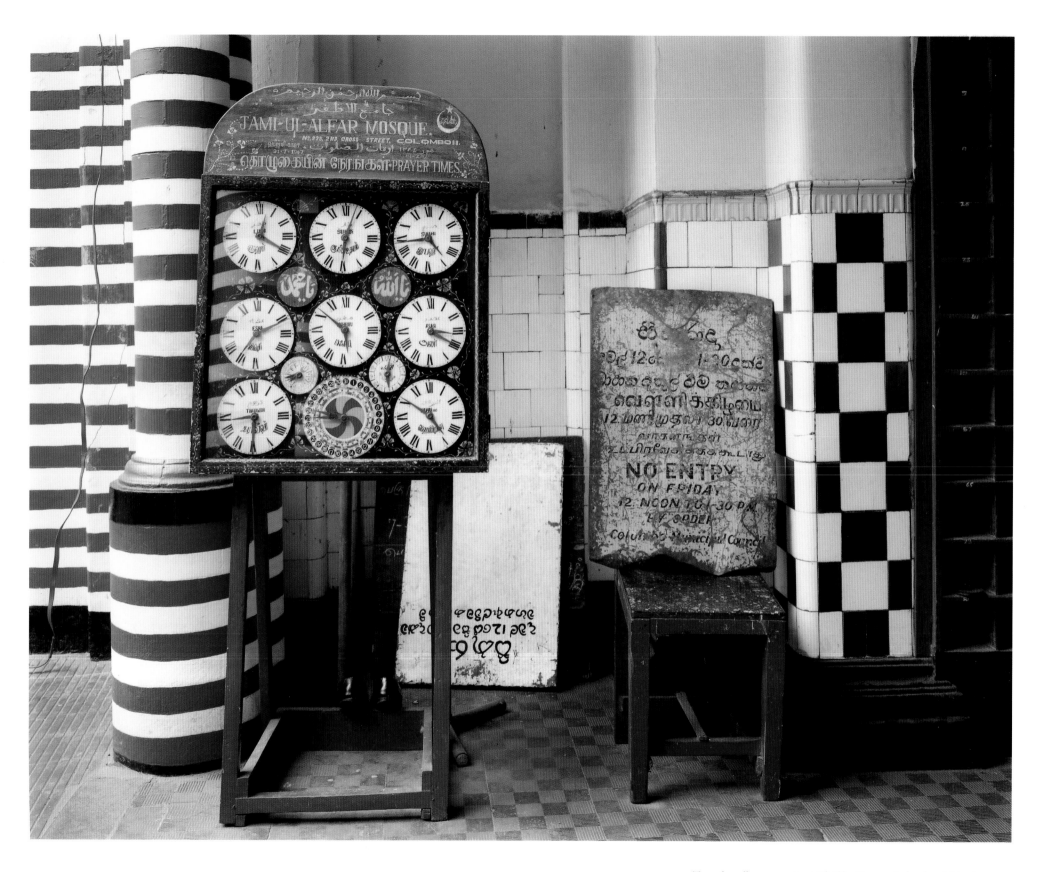

Times for call to prayer, Jami-Ul-Alfar Mosque, Colombo, Sri Lanka, 1993

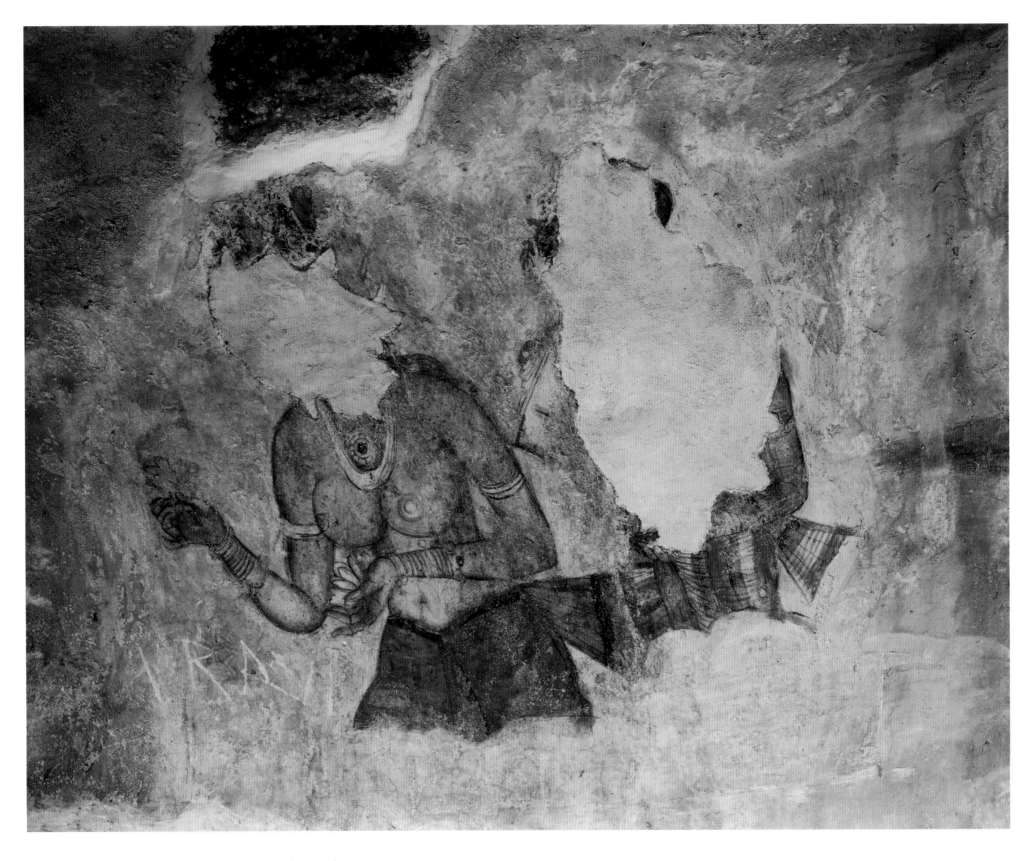

Fifth-century fresco defaced by a vandal in 1967, Sigiriya Rock, Sri Lanka, 1993

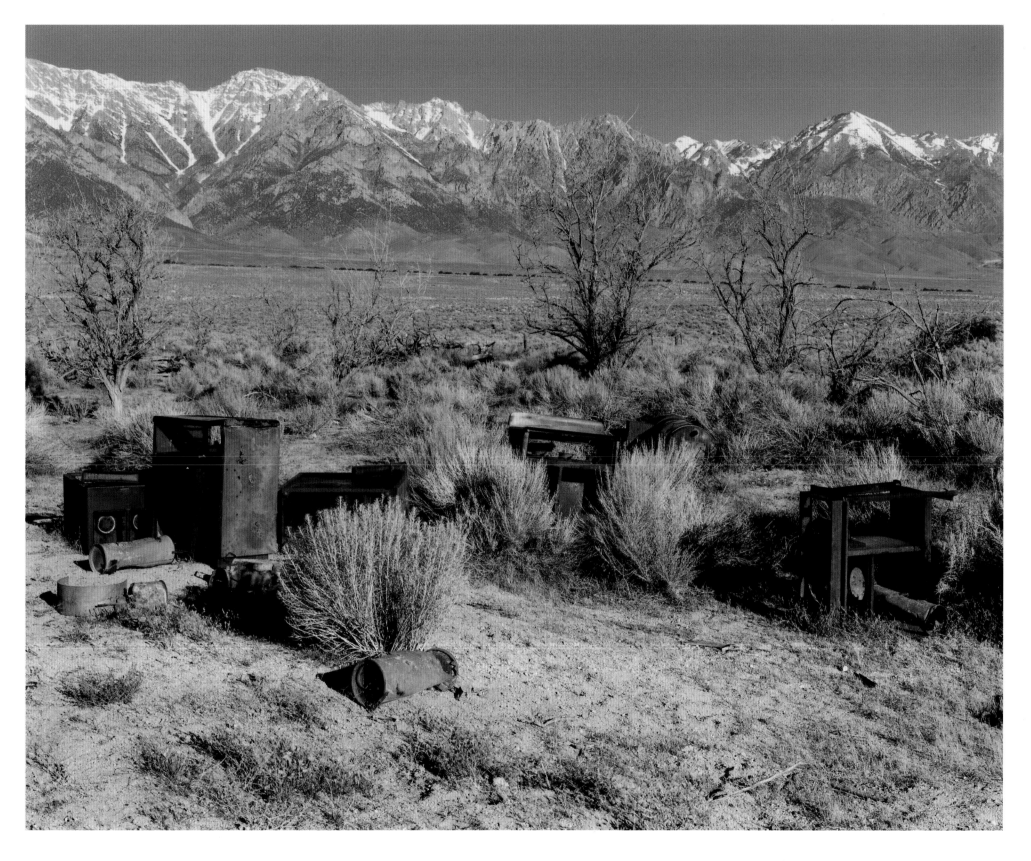

Apple orchard, Manzanar Japanese-American Relocation Camp, Owens Valley, California, 1995

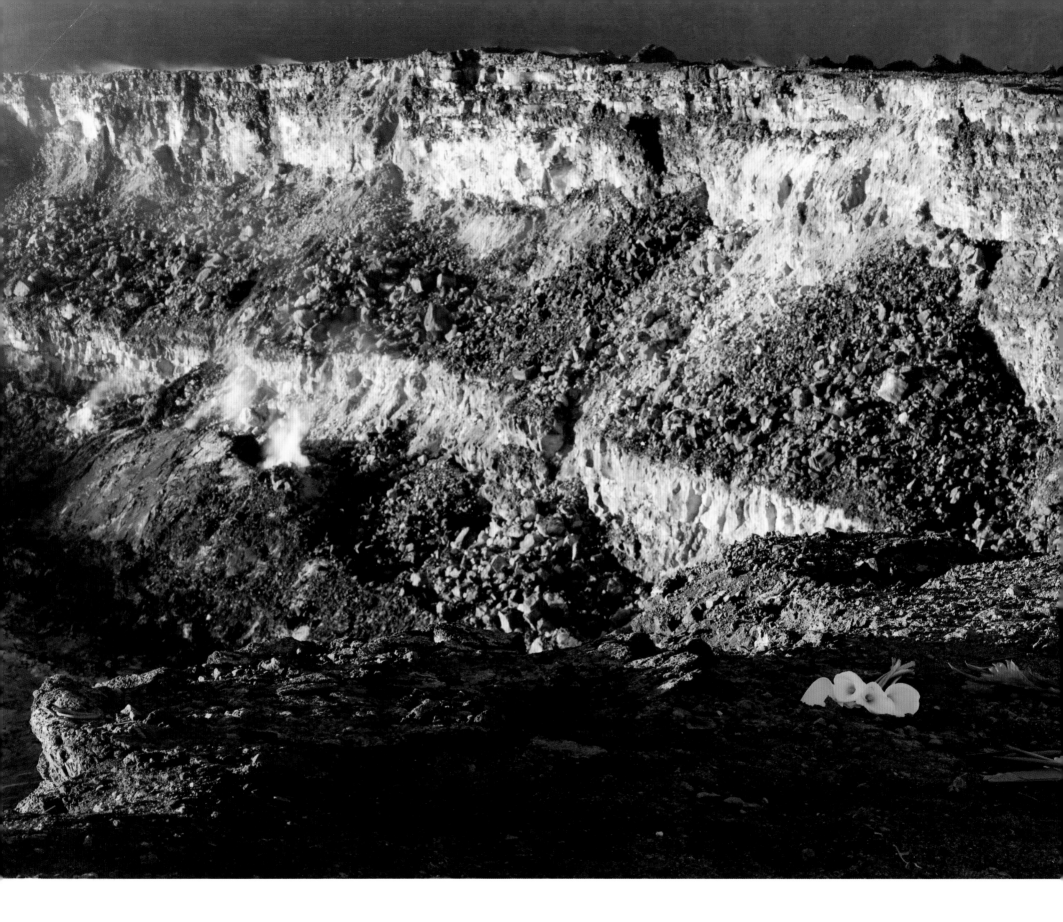

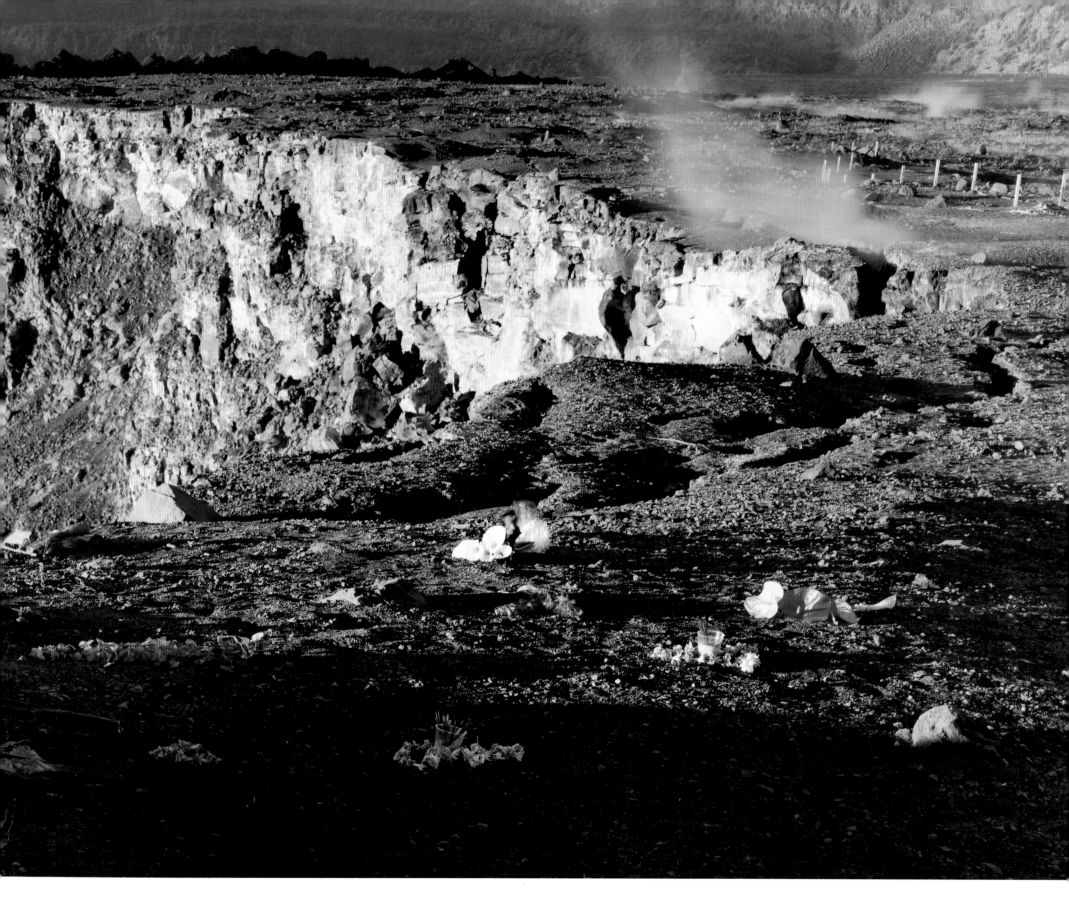

Offerings to the goddess Péle at the rim of Kilauea Crater, Hawai'i, 1990

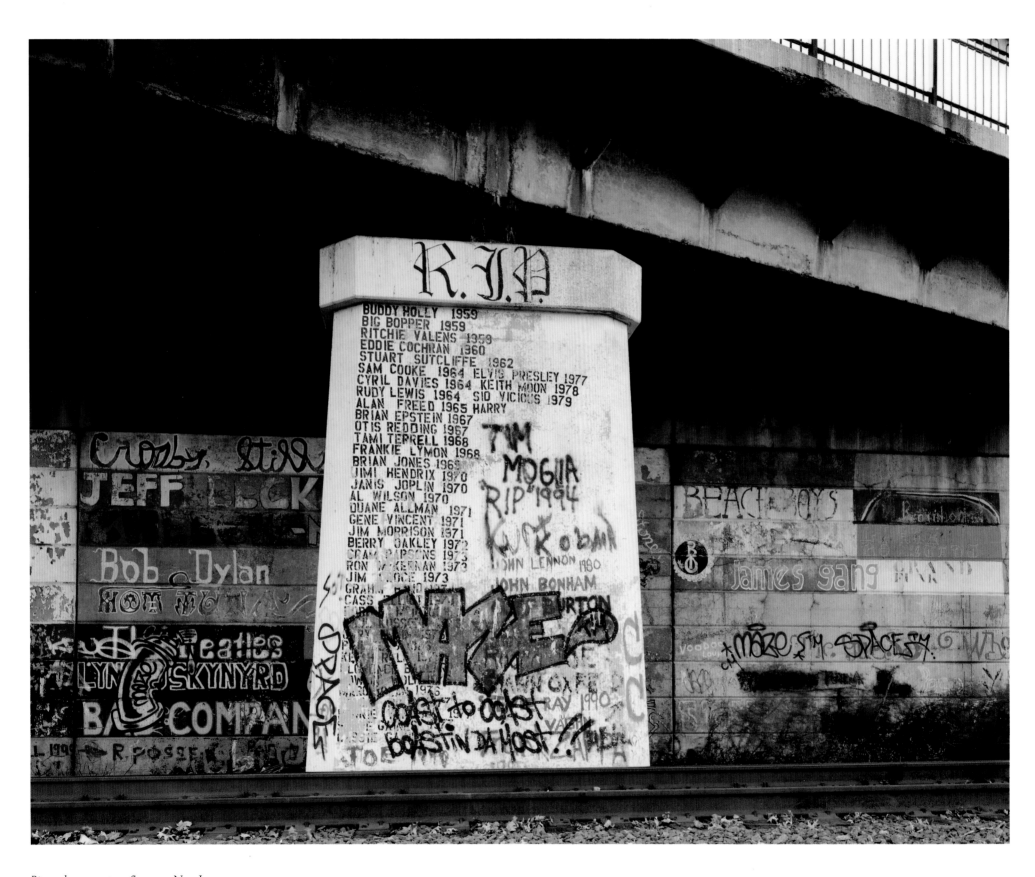

Pier under an overpass, Sewaren, New Jersey, 1997

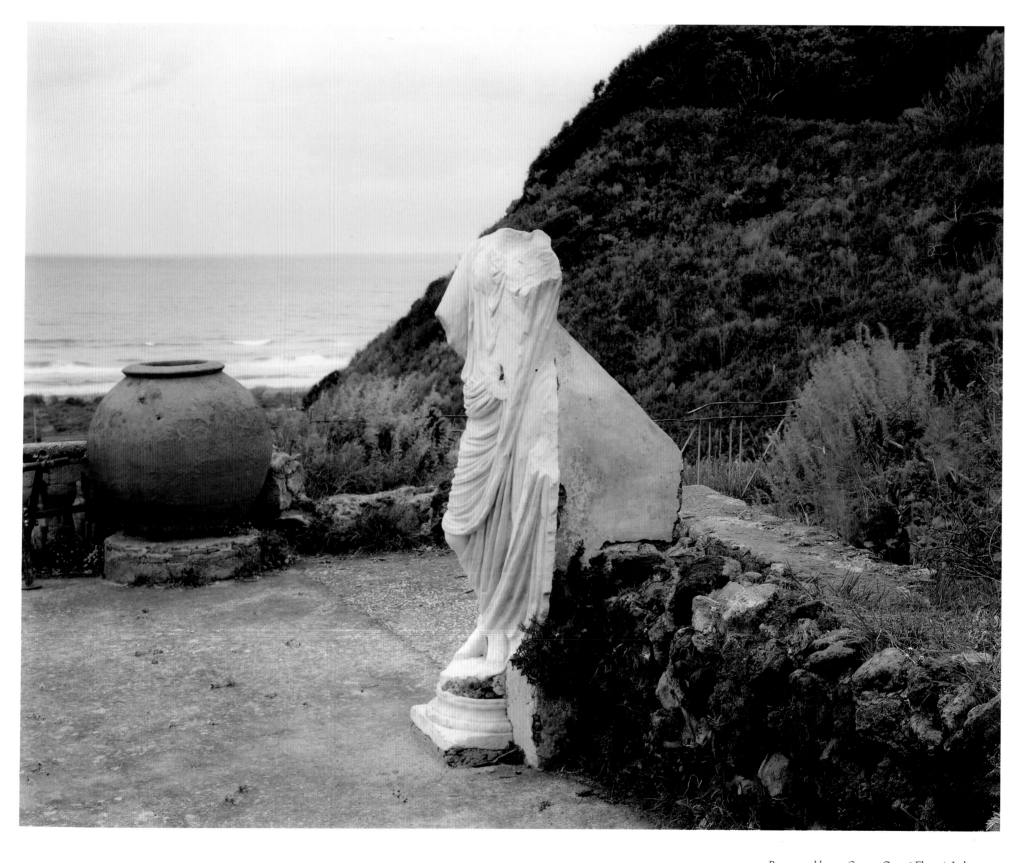

Roman goddess at Cumae, Campi Flegrei, Italy, 1994

Cultivating
THE LAND

Wherever they went, Europeans immediately began to change the local habitat; their conscious aim was to transform territories in places as far away from Europe as South America and Australia into images of what they left behind. This process was never-ending, as a huge number of plants, animals, crops, and farming as well as building methods invaded the colony and gradually turned it into a new place.

—EDWARD SAID, "Yeats and Decolonization"

Most Americans celebrate nature as the world of original things. And nature may indeed be the world we have not made—the world of plants, animals, trees, and mountains—but the boundaries between this world of nature and the world of artifice, the world of things we have made, are no longer very clear. Are the cows and crops we breed, the fields we cultivate, the genes we splice, natural or unnatural?

—RICHARD WHITE, "Are you an Environmentalist
or Do You Work for a Living?"

Tea plantations first planted by the British, now locally owned, Hatton Road, Sri Lanka, 1993

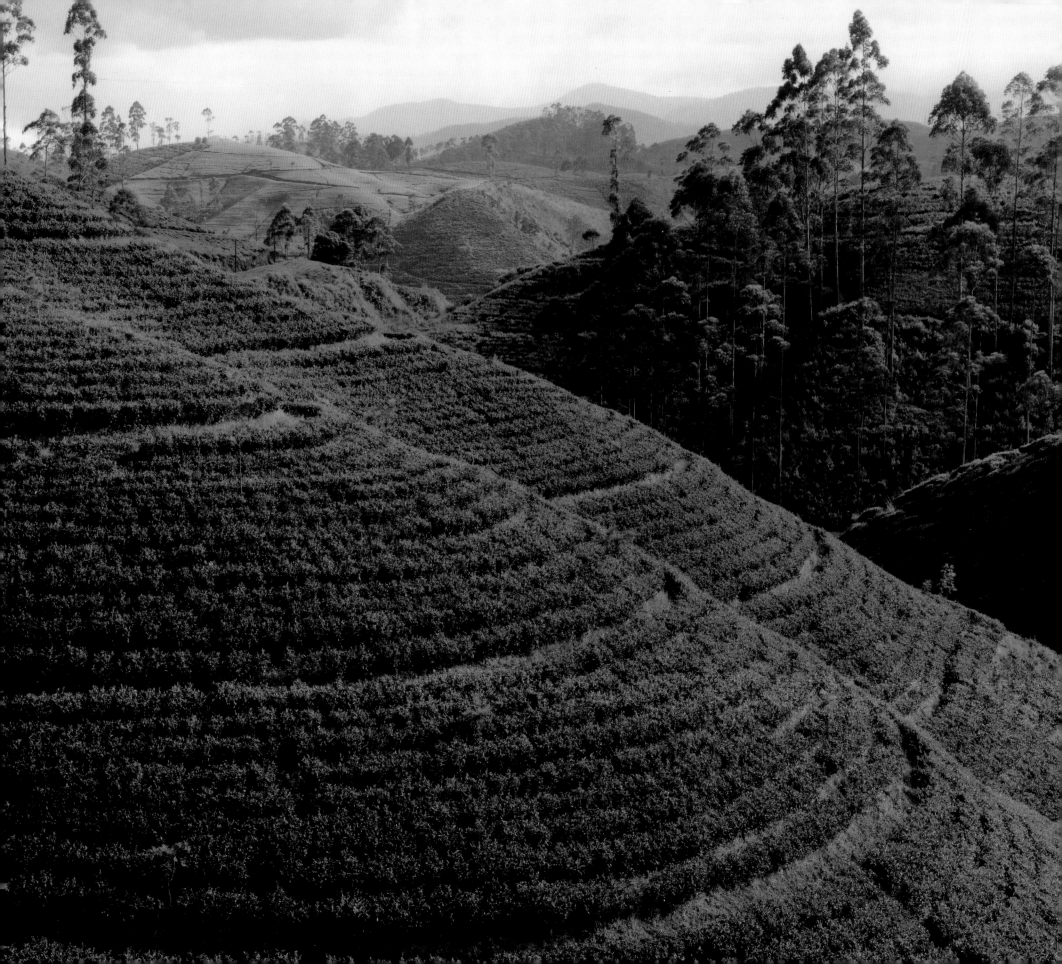

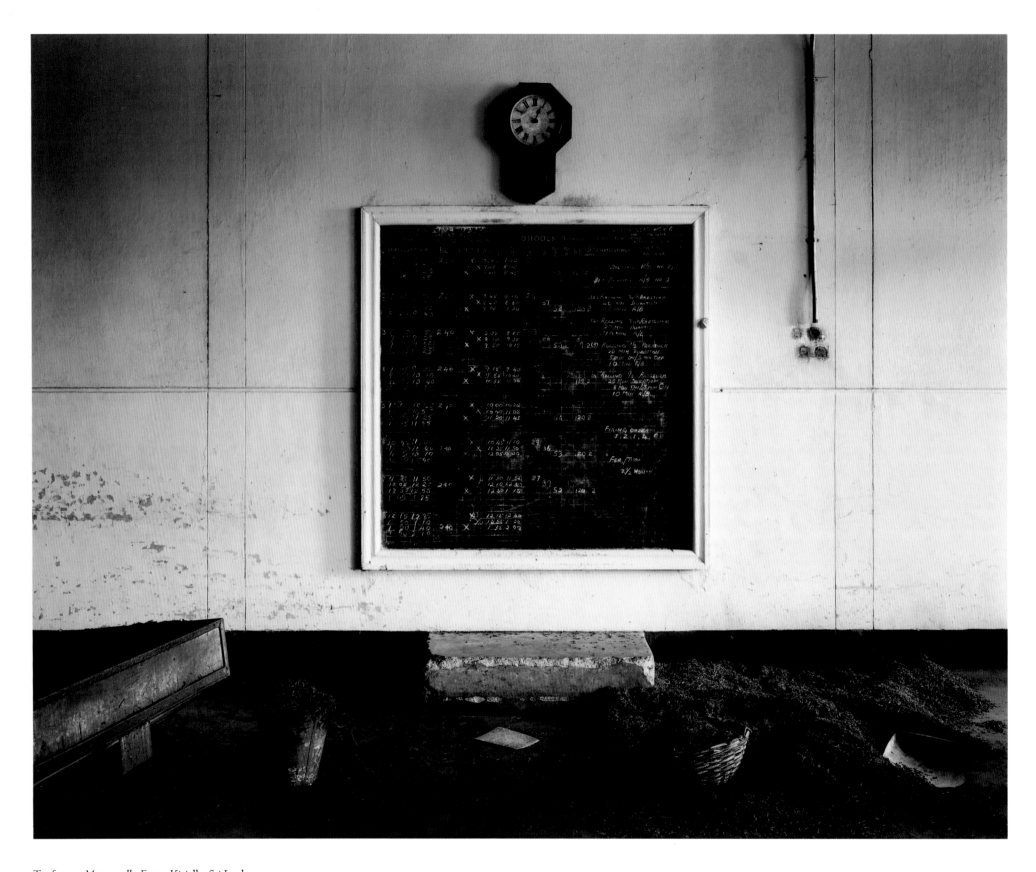

Tea factory, Mutwagalla Estate, Kiriella, Sri Lanka, 1993

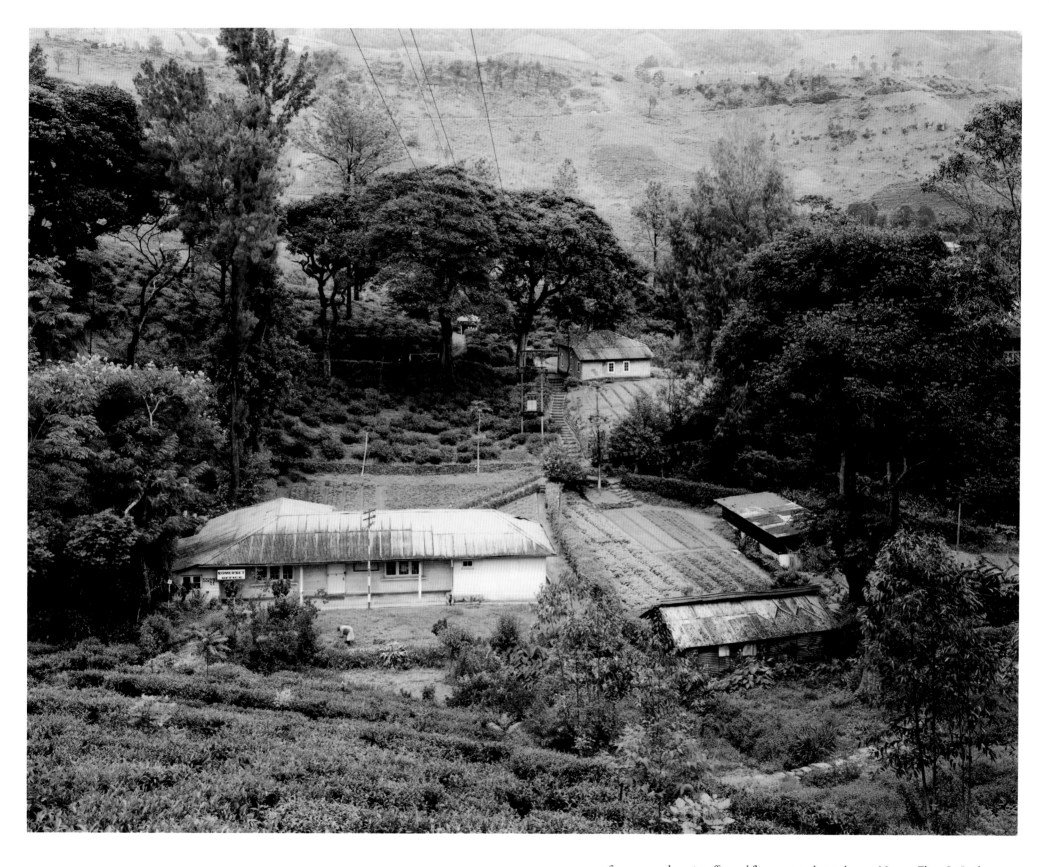

Somerset tea plantation office and flame trees in the jungle, near Nuwara Eliya, Sri Lanka, 1993

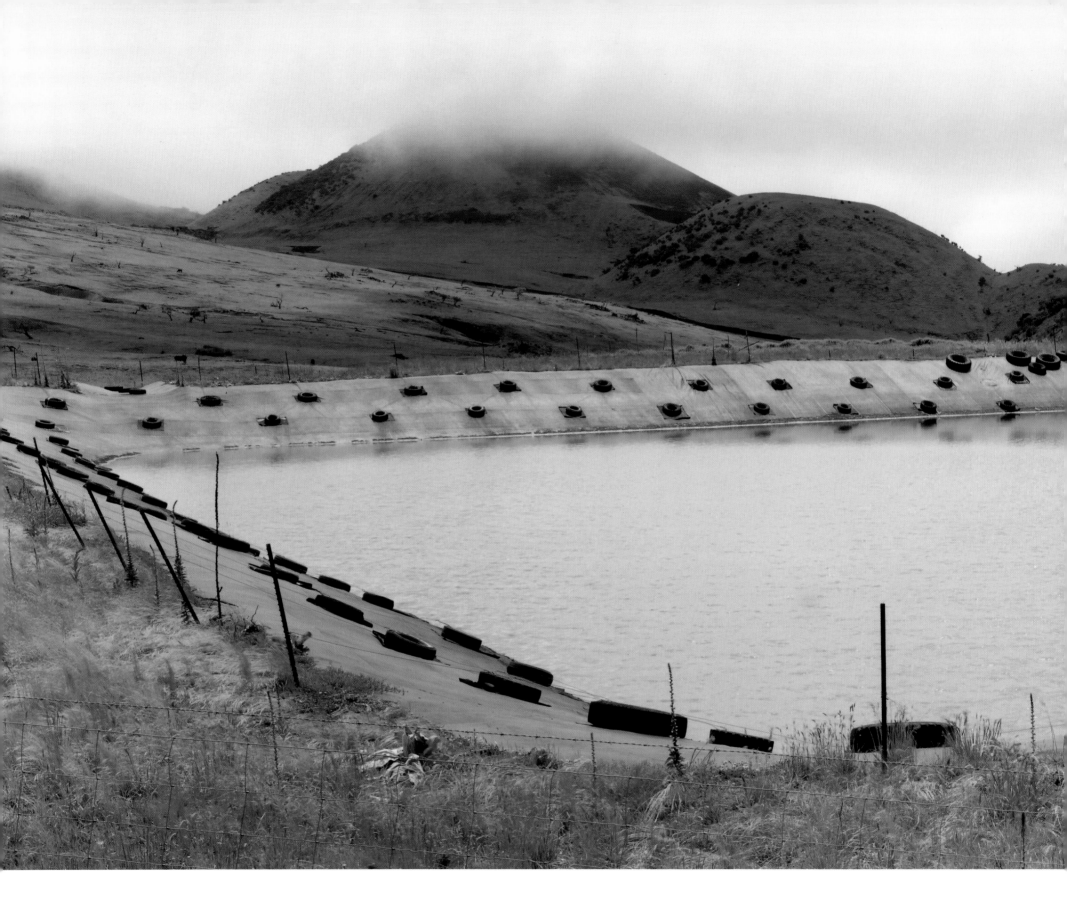

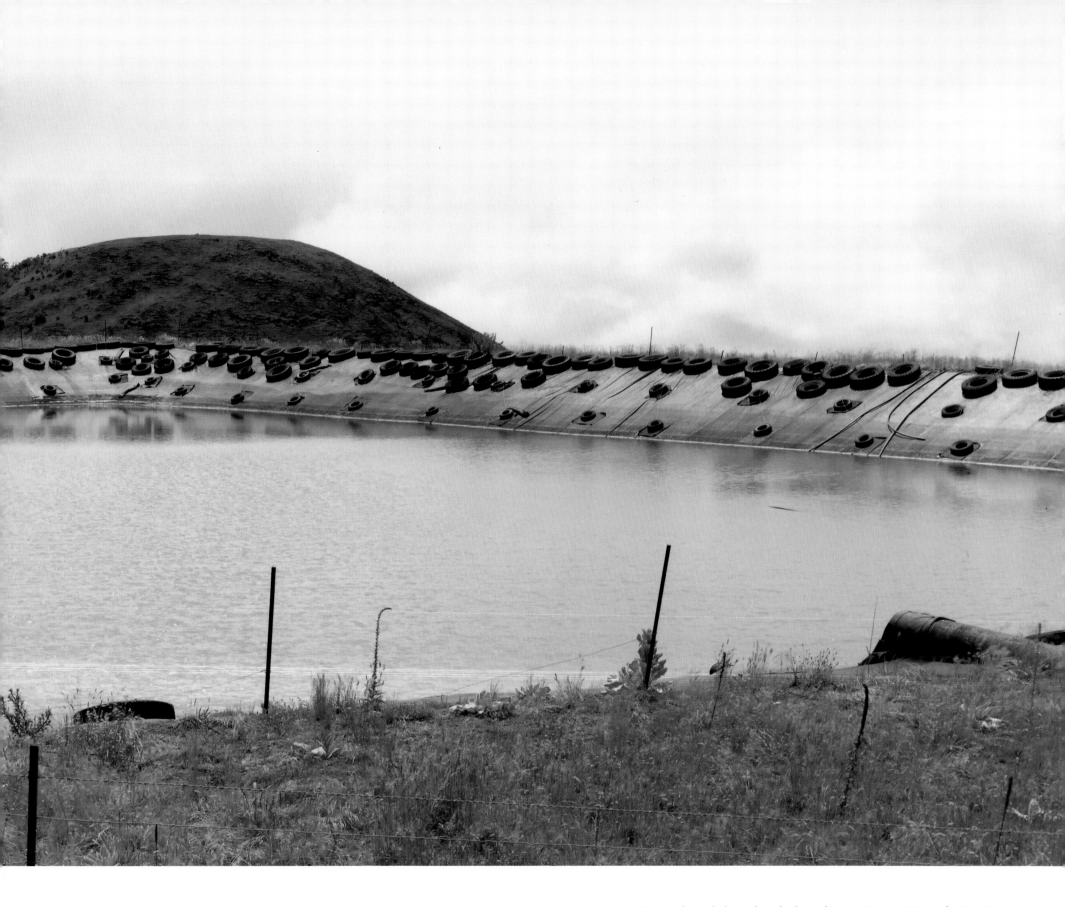

Water catchment for livestock on the slopes of Mauna Kea, near Humu'ula, Hawai'i, 1990

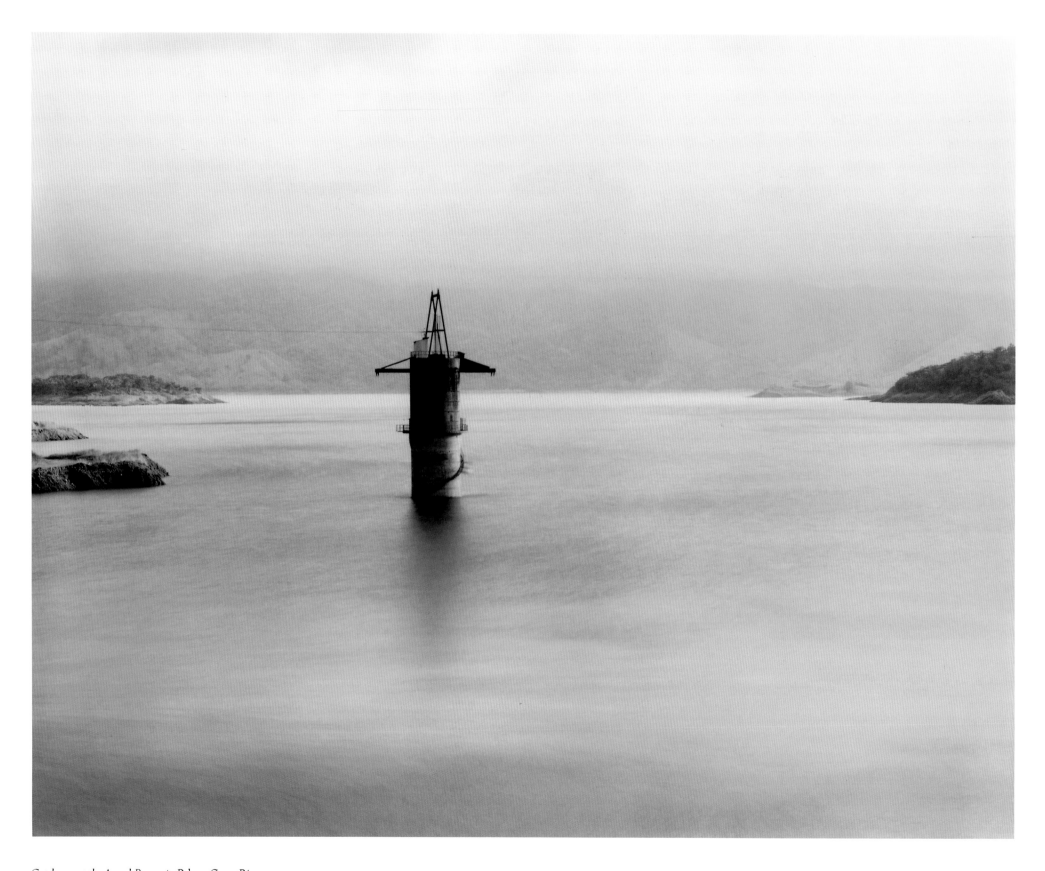

Gatehouse at the Arenal Reservoir, Palma, Costa Rica, 1992

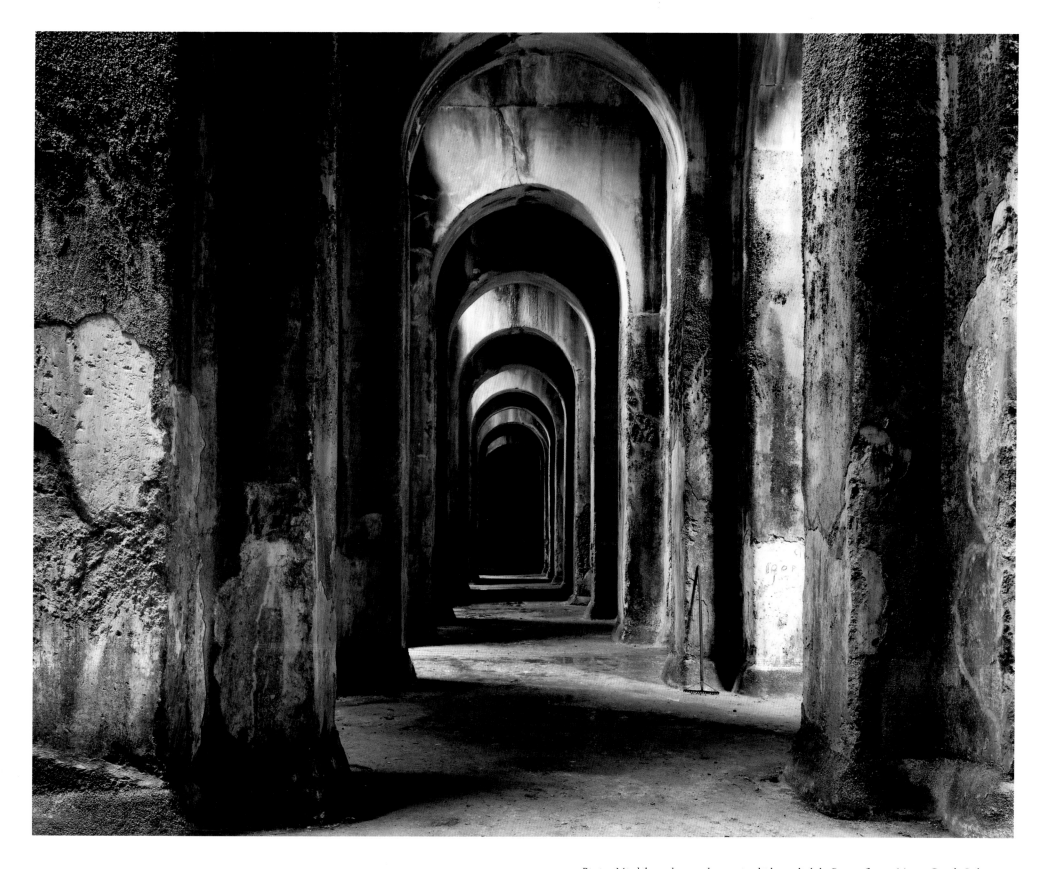

Piscina Mirabile, underground reservoir which supplied the Roman fleet at Misena, Bácoli, Italy, 1994

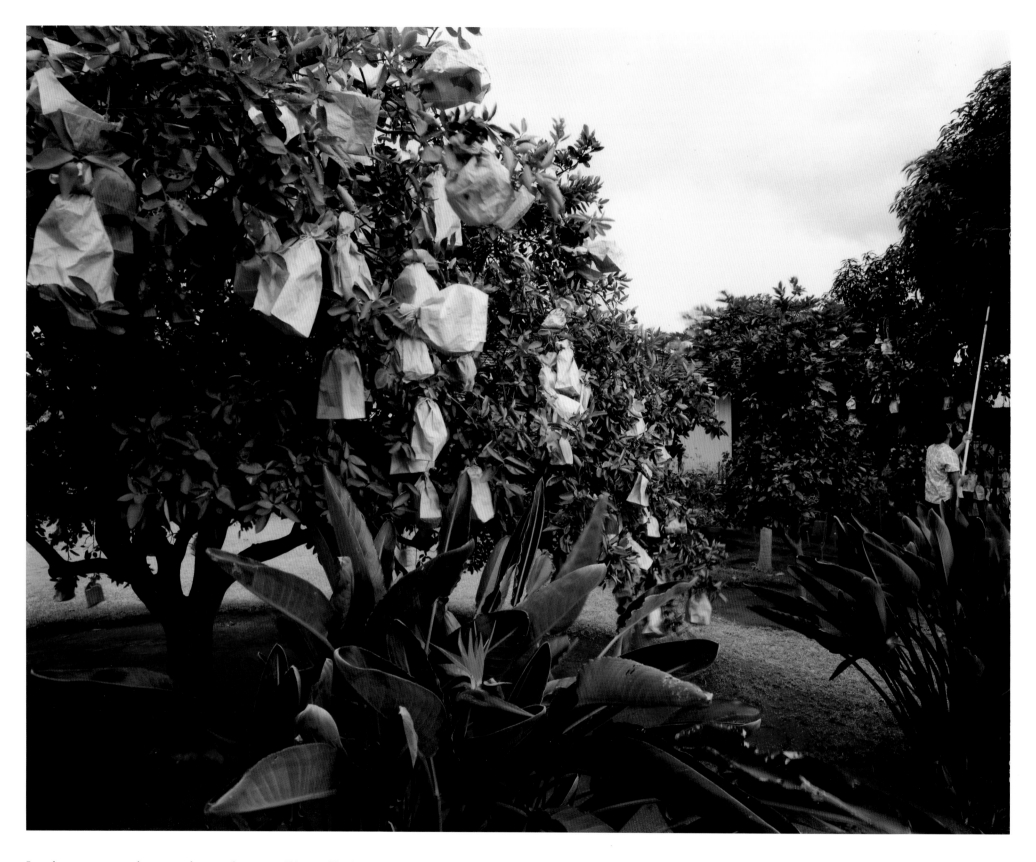

Paper bags protecting navel oranges and mangos from insects, Waimea, Kauaʻi, 1991

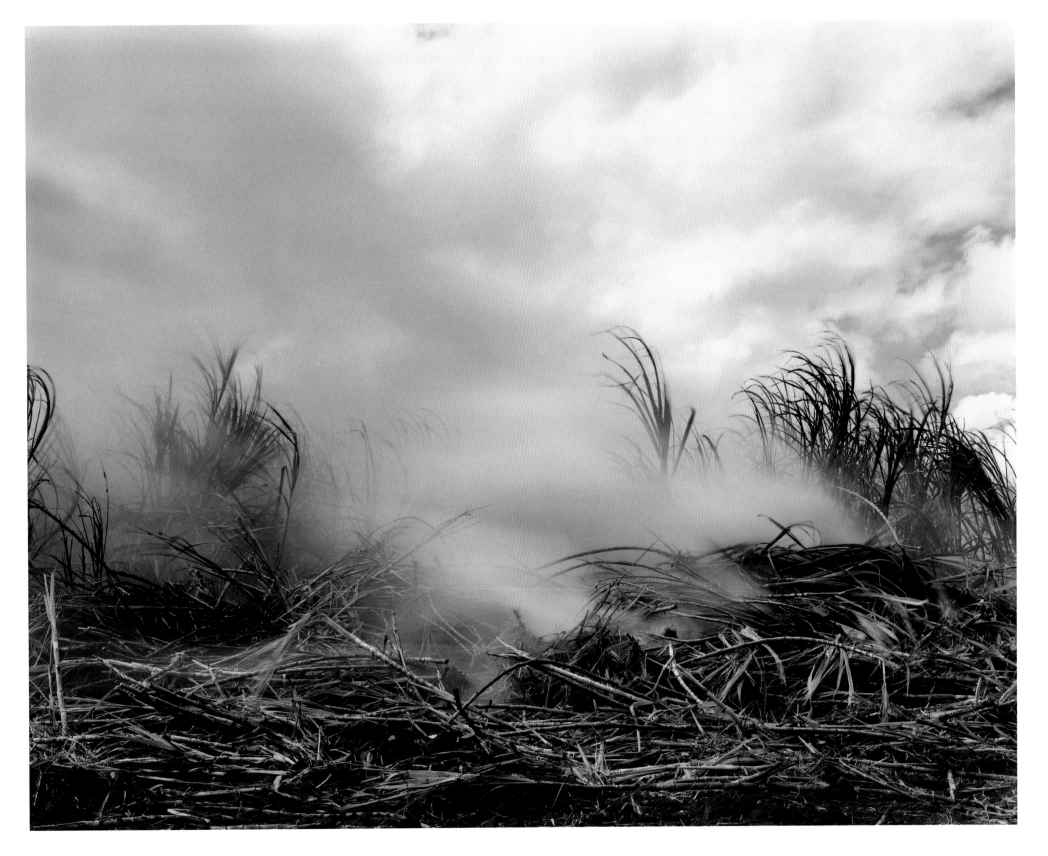

Sugar cane burning before harvest, Puhi, Kaua'i, 1991

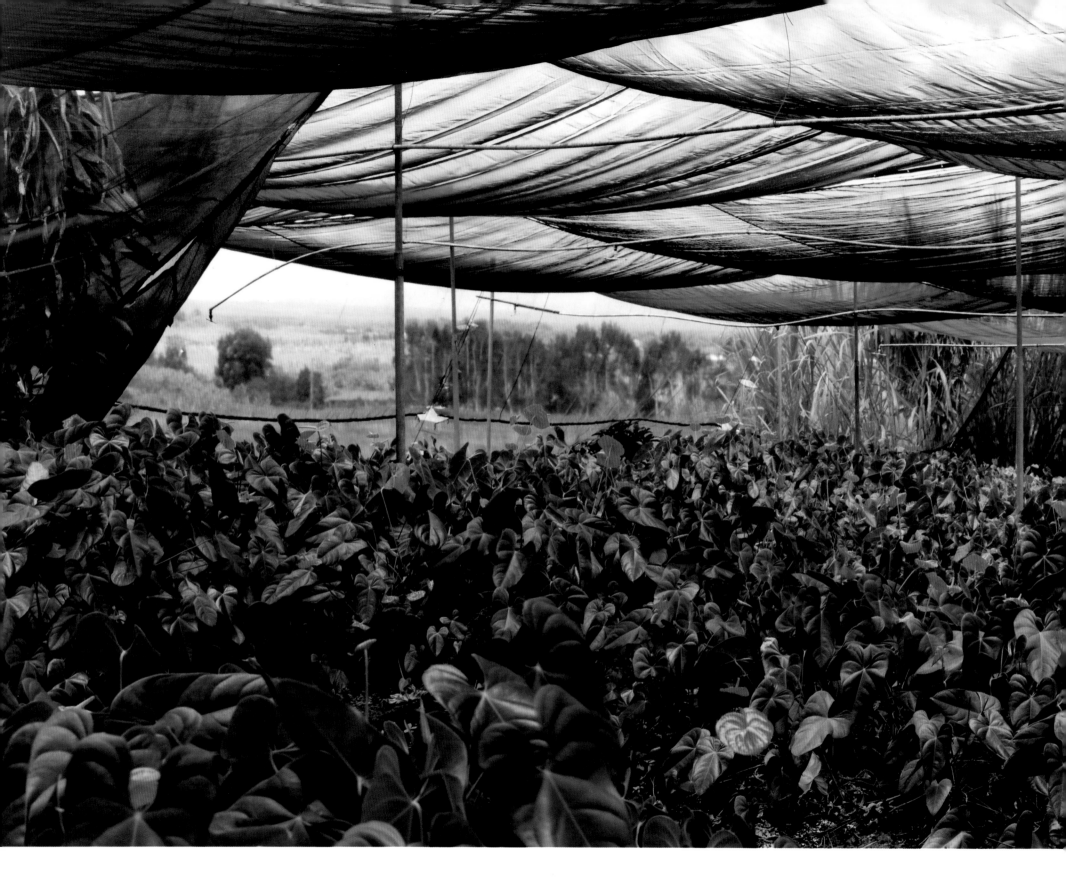

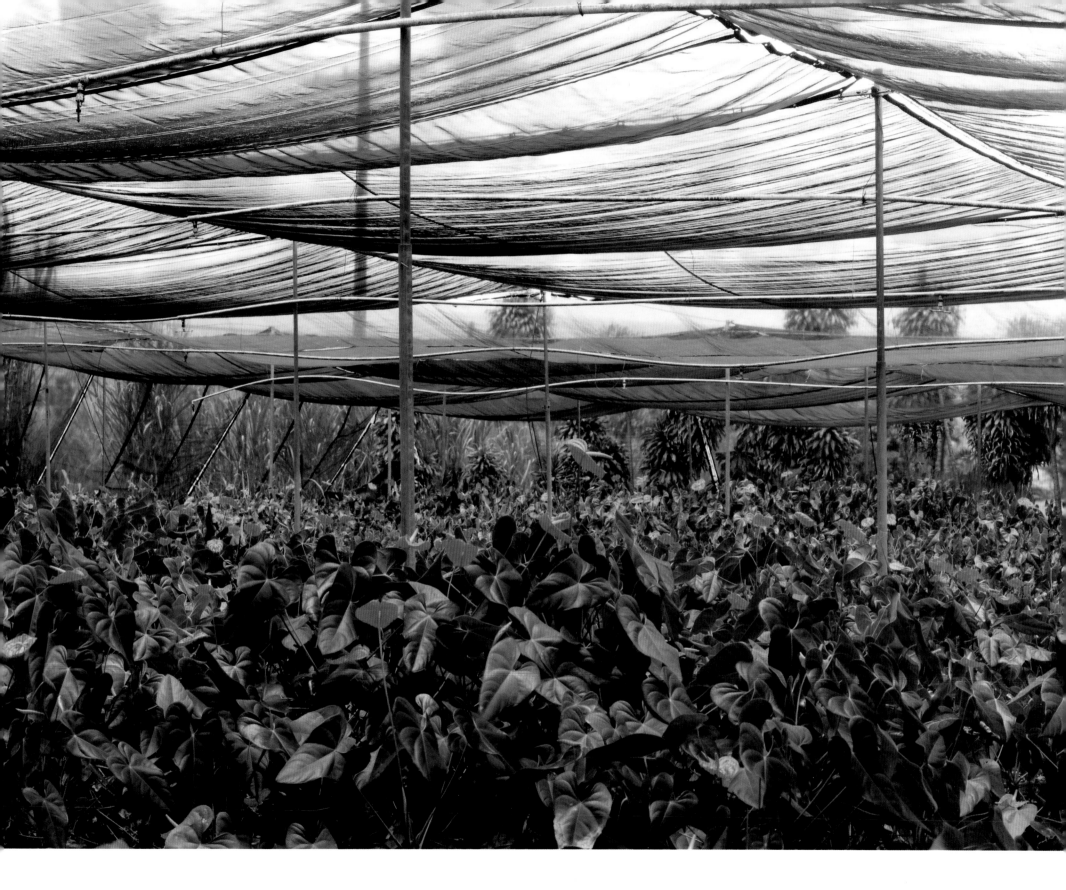

Anthurium farm on the slopes of Mauna Loa, Kurtistown, Hawai'i, 1990

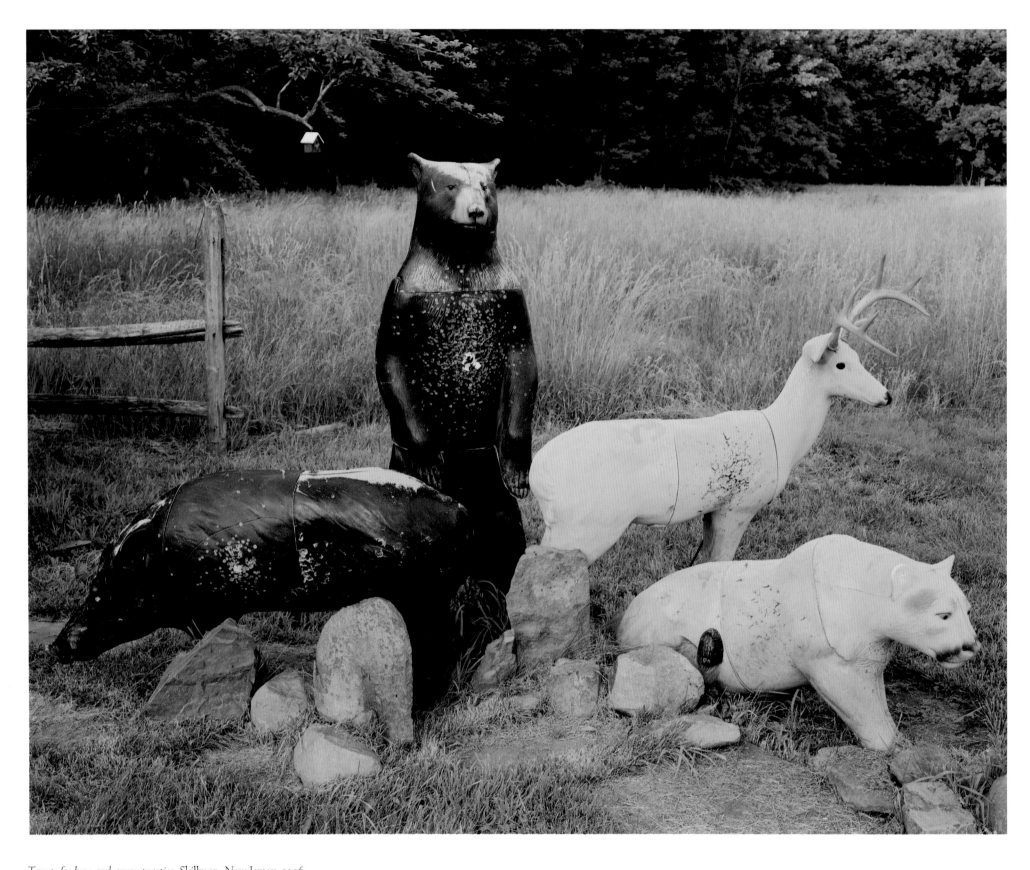

Targets for bow and arrow practice, Skillman, New Jersey, 1996

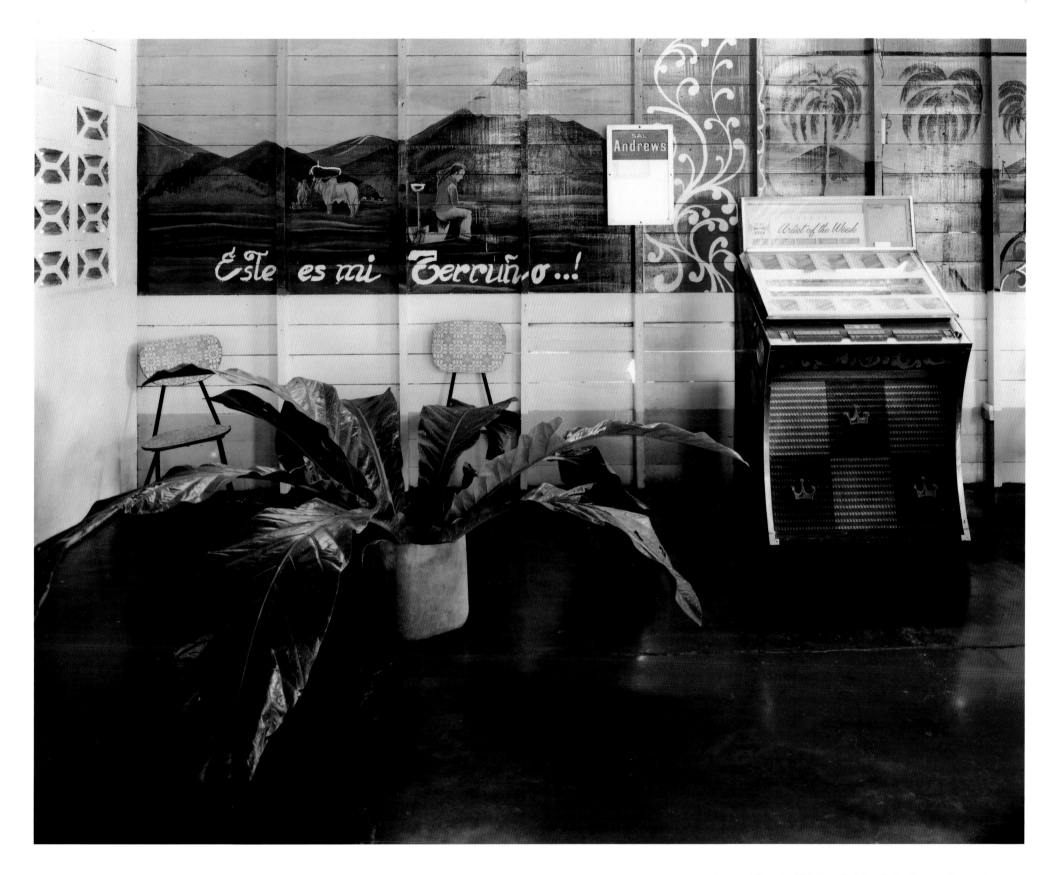

Este es mi Terruño (This is my little land), La Fortuna, Costa Rica, 1992

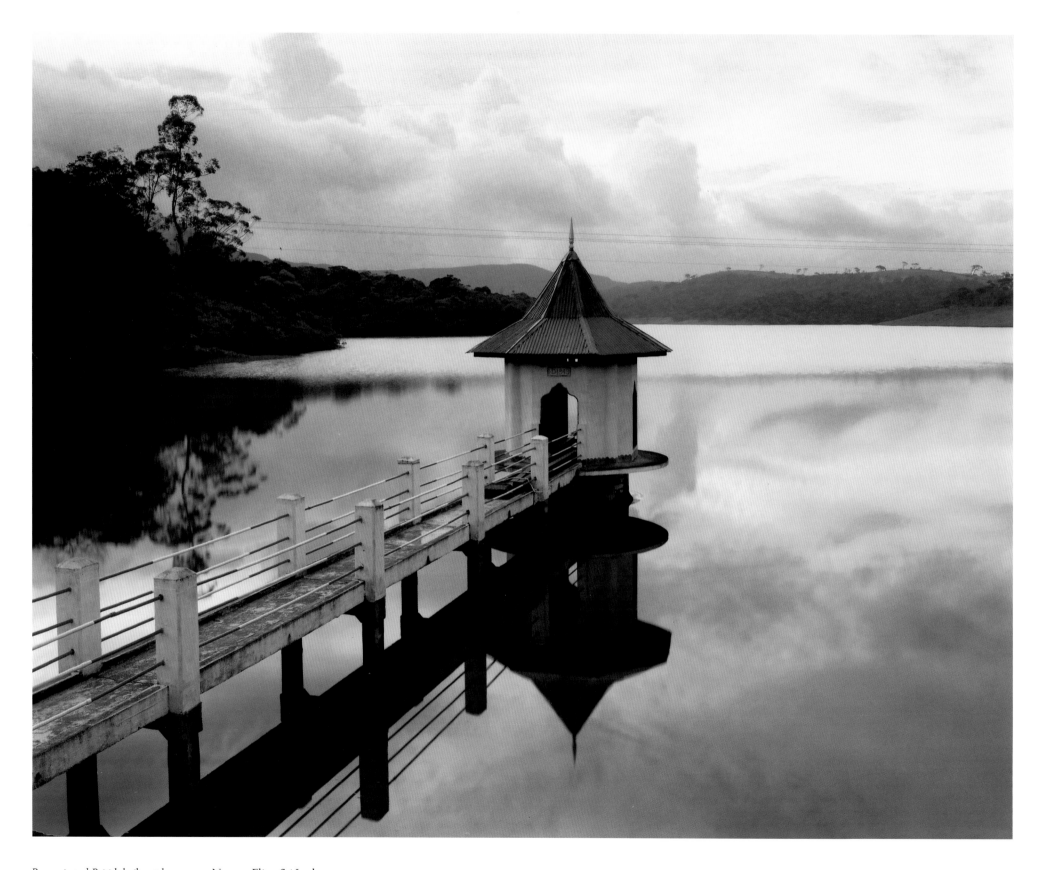

Reservoir and British-built gatehouse, near Nuwara Eliya, Sri Lanka, 1993

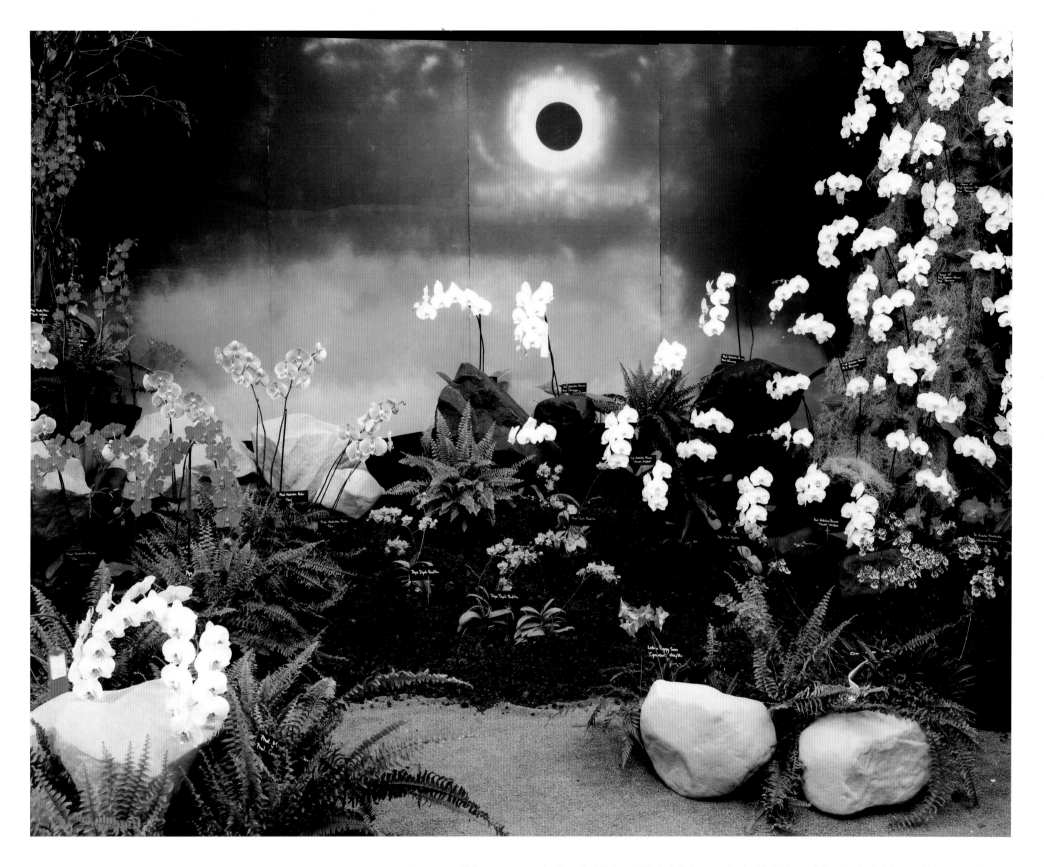

Depiction of July 11, 1991 total eclipse for "Galaxy of Orchids," the annual 4th of July show of the Hilo Orchid Society, Hilo, Hawai'i, 1991

Green Thumb Garden, Morningside Heights, New York, 1997

Sidewalk shop, Limón, Costa Rica, 1992

Butterfly farm, La Guácima, Costa Rica, 1992

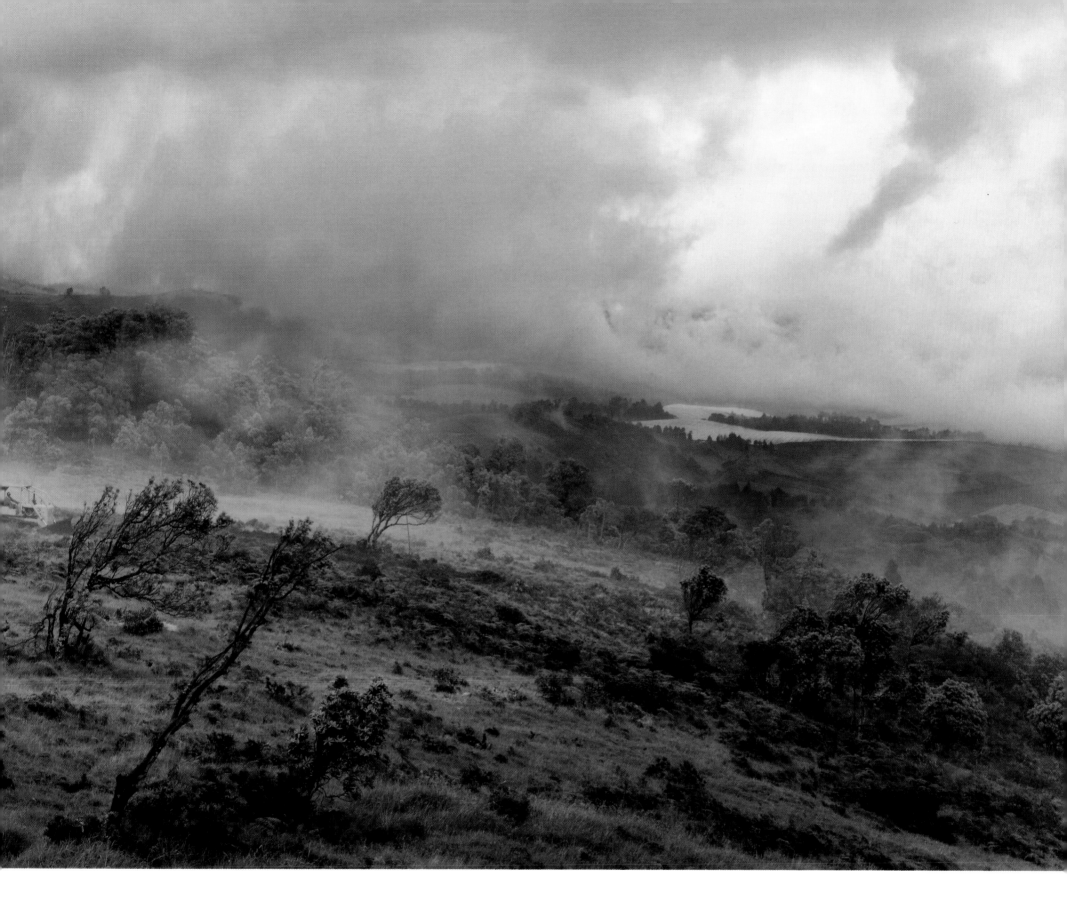

Clearing land for agriculture on the slopes of Poás Volcano, near Fraijanes, Costa Rica, 1992

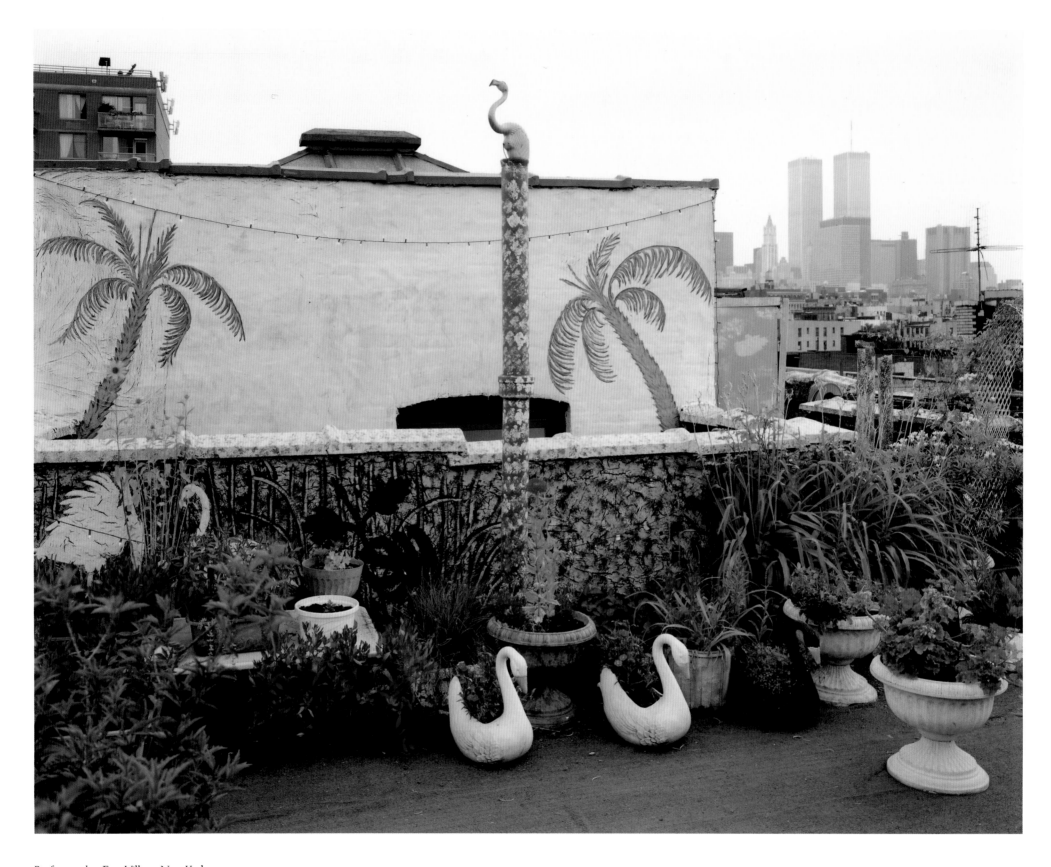

Rooftop garden, East Village, New York, 1997

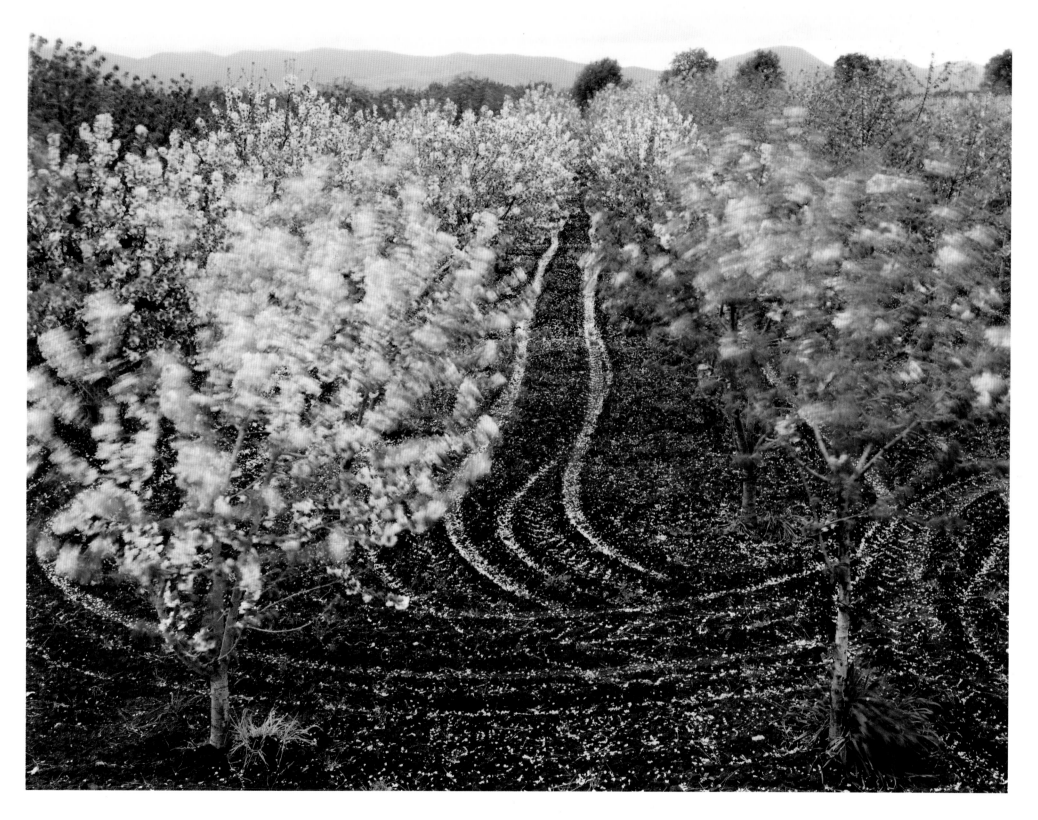

Cherry trees blooming, Sparanise, Italy, 1994

A Fragile ALLIANCE

In the broadest sense of the term, landscape is a way of seeing the world and imagining our relationship to nature. It is something we think, do, and make as a social collective. Thus it is as much a social as a geographical history. It comes back to the land over and again, but it is a land understood as both subject and object, an agent of historical processes as well as the field of human action. . . .

The terms of survival into the next century will not be found within the technological arena but from within the culture that surrounds and produces it. We urgently need to imagine environments which are not about domination. . . . We need to tell new stories about settlement and work on this Earth.

—Alexander Wilson, *The Culture of Nature*

Sluices at a reservoir, part of a two-thousand-year-old irrigation system now updated, near Badulla, Sri Lanka, 1993

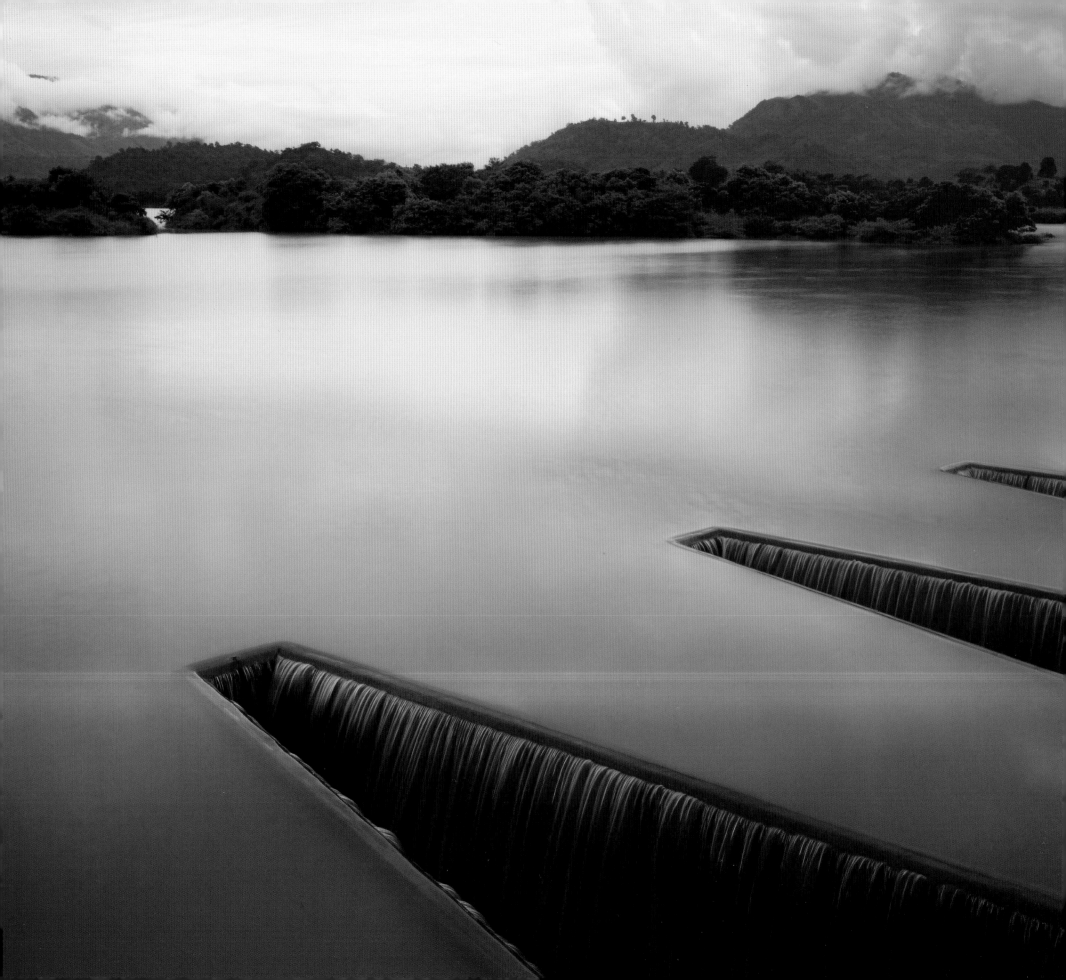

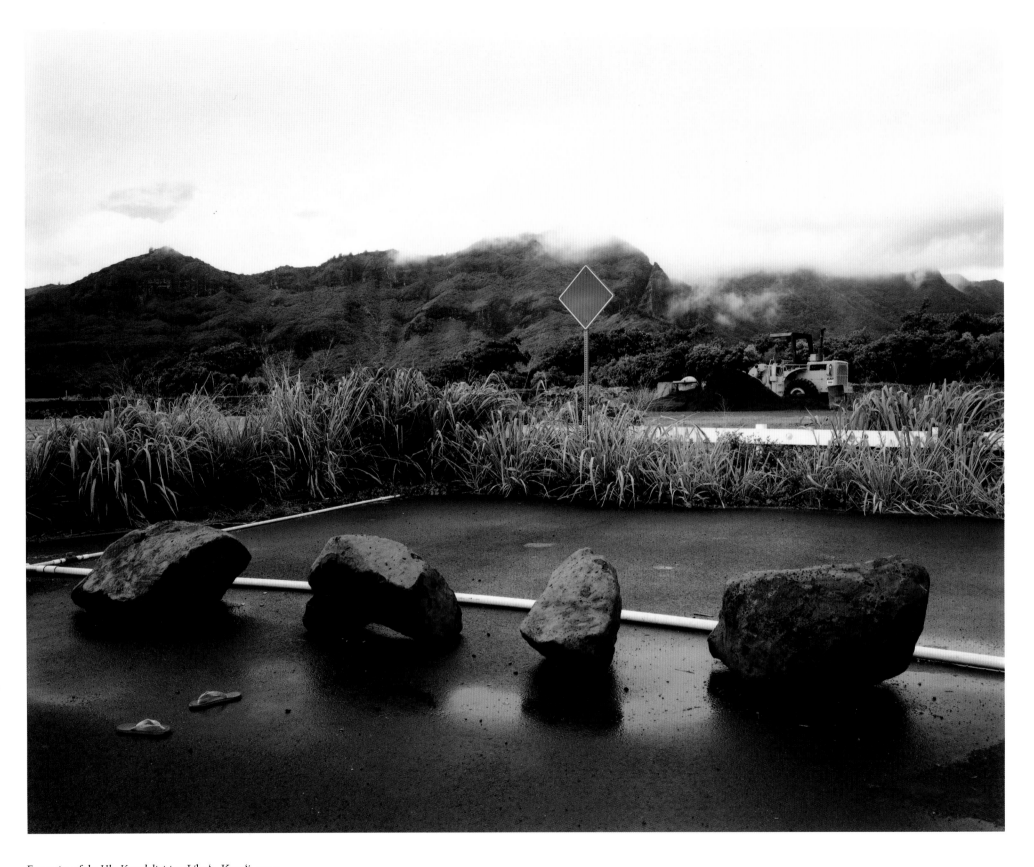

Expansion of the Ulu Ko subdivision, Lihuʻe, Kauaʻi, 1991

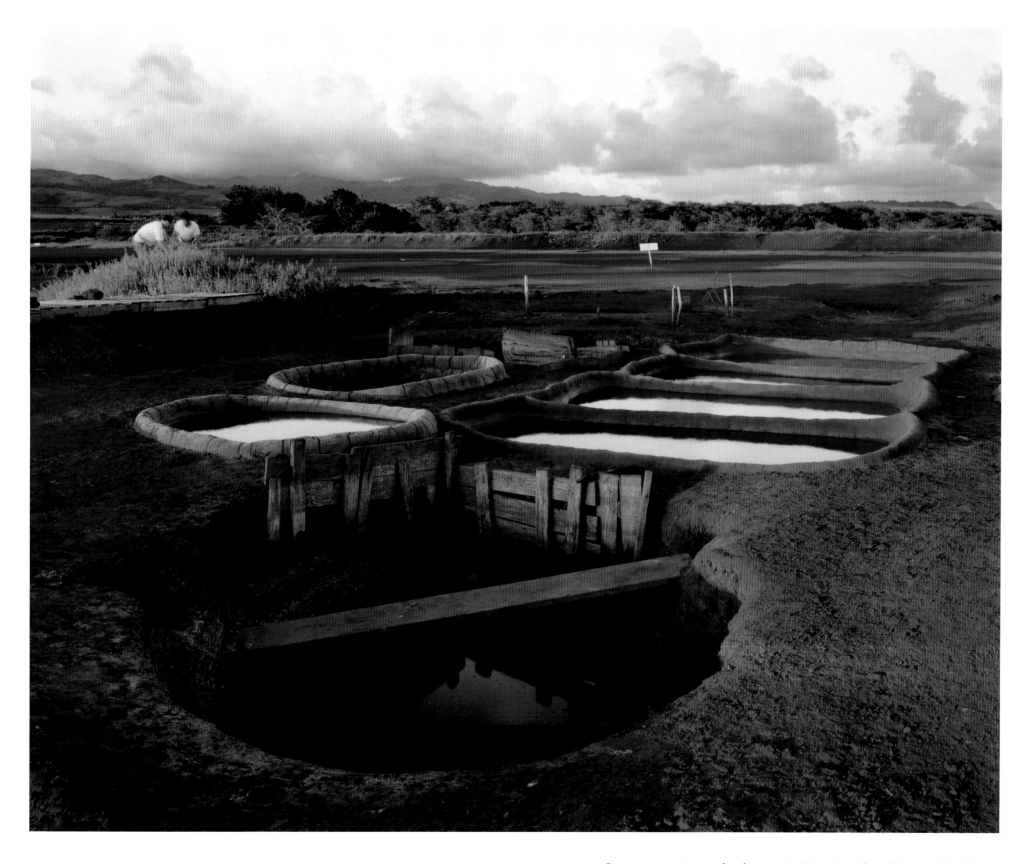

Seawater evaporating to make salt, an ancient Hawaiian tradition, Hanapēpē, Kauaʻi, 1991

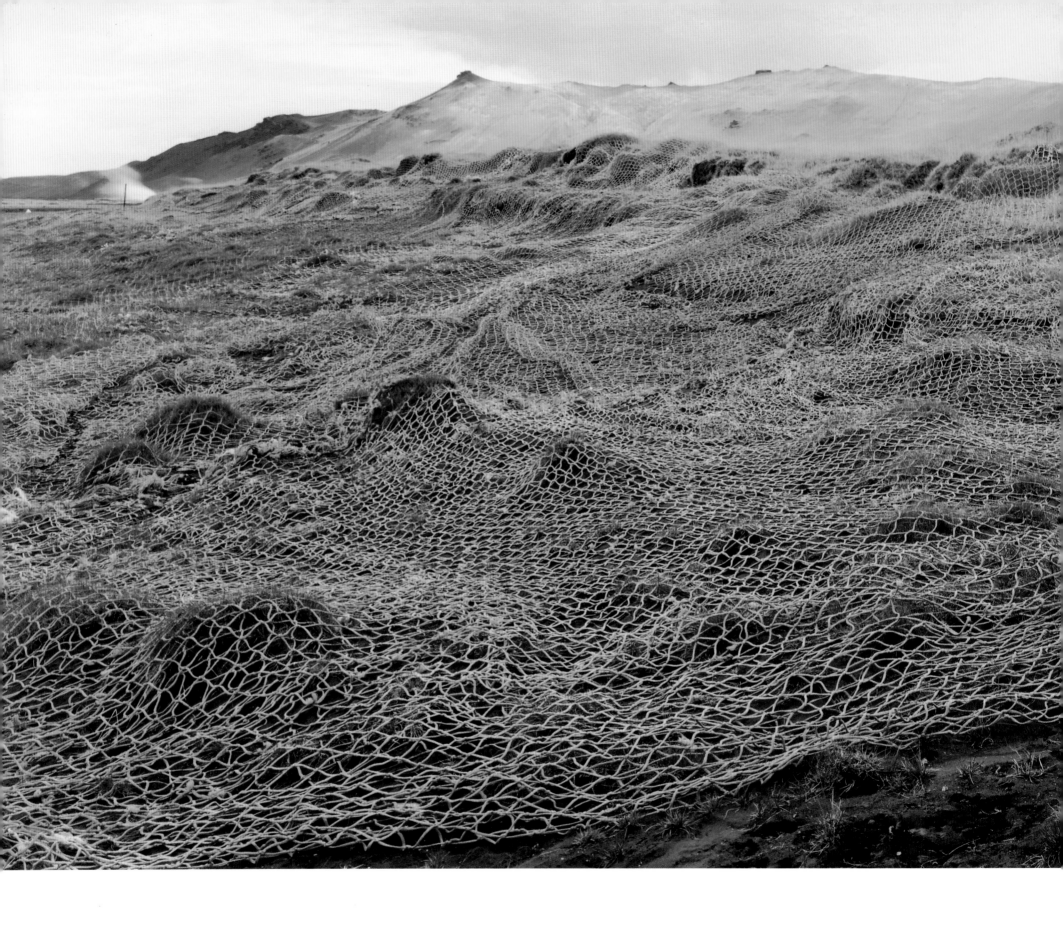

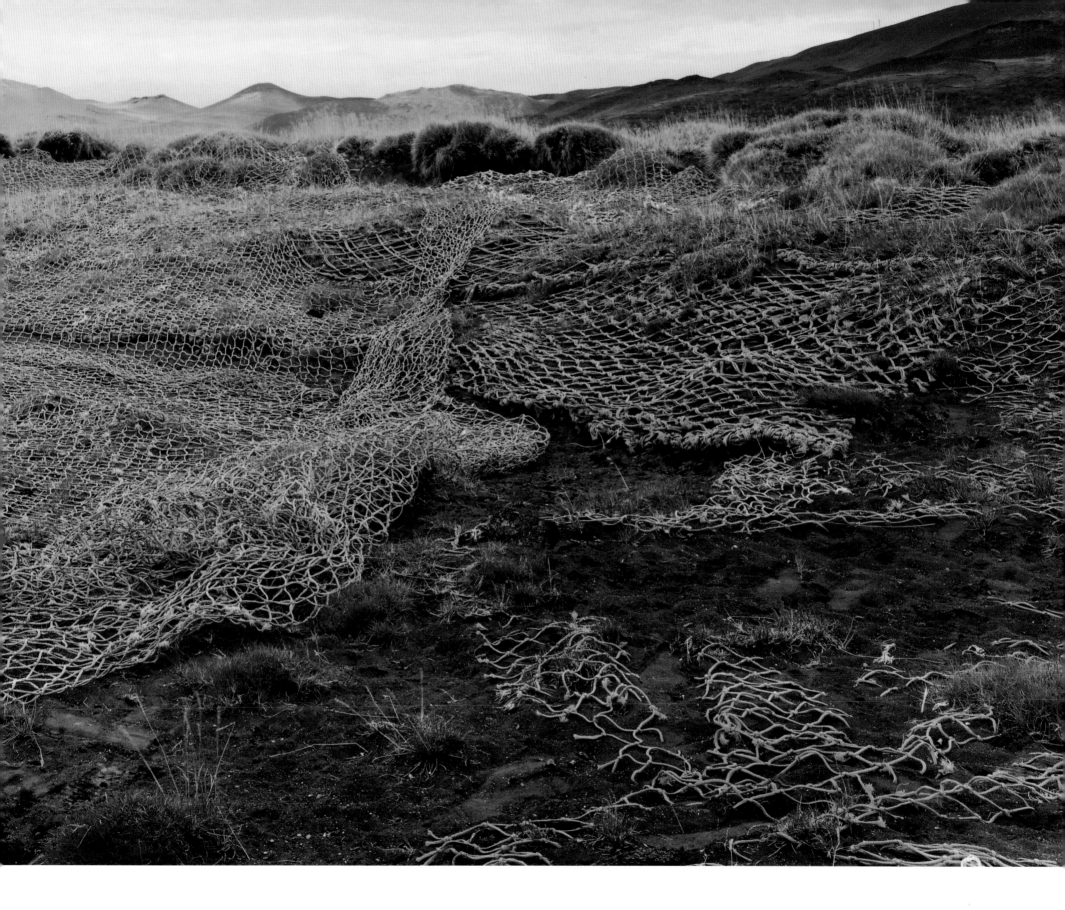

Fishing net used to control erosion in deforested landscape, Hlídarfjall, Iceland, 1987

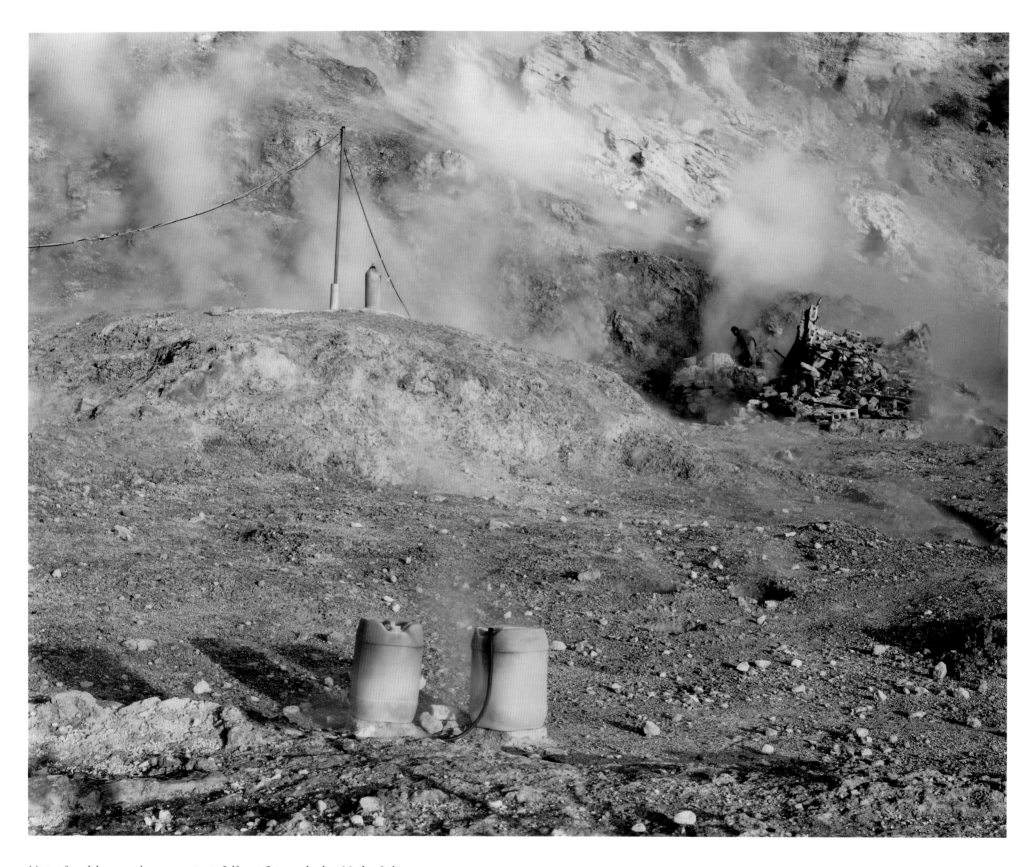

Mining for sulphur near observatory ruins in Solfatara Crater, suburban Naples, Italy, 1994

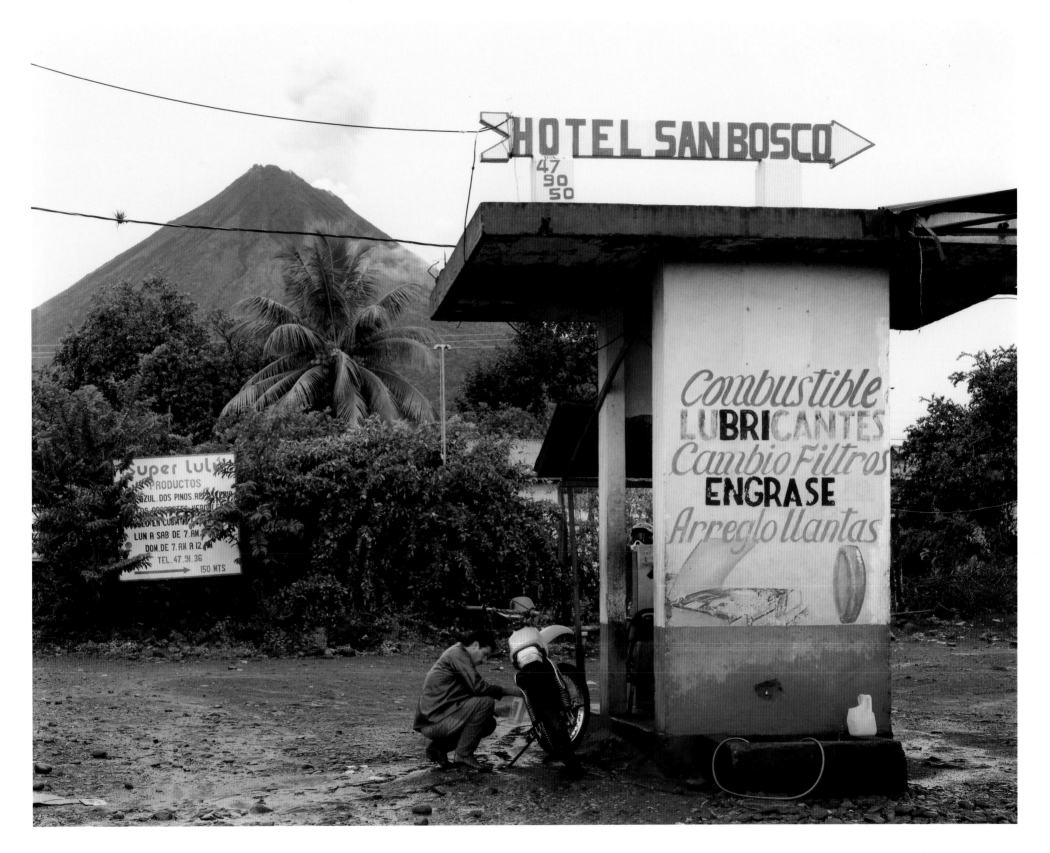

View of Arenal Volcano from the town of La Fortuna, San Carlos, Costa Rica, 1992

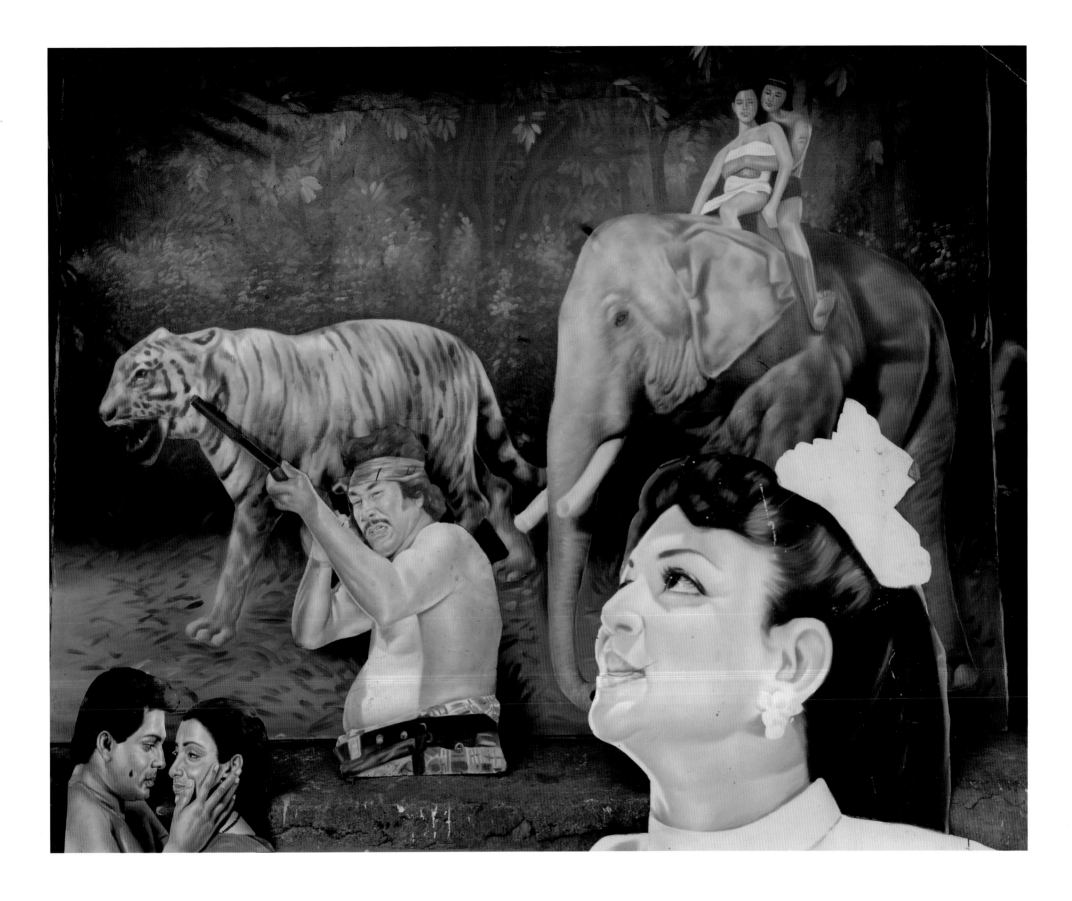

Jungle scene at Prem Jayanth's movie-billboard painting studio, Colombo, Sri Lanka, 1993

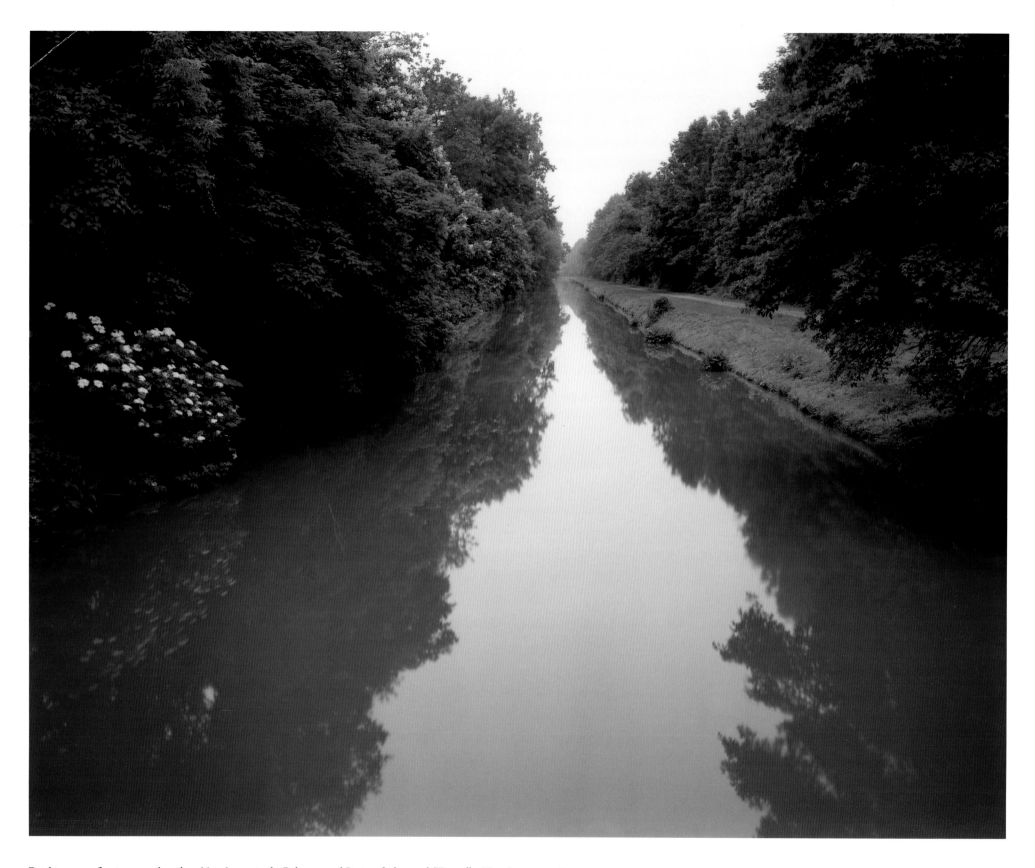

Drinking water flowing toward northern New Jersey via the Delaware and Raritan feeder canal, Titusville, New Jersey, 1996

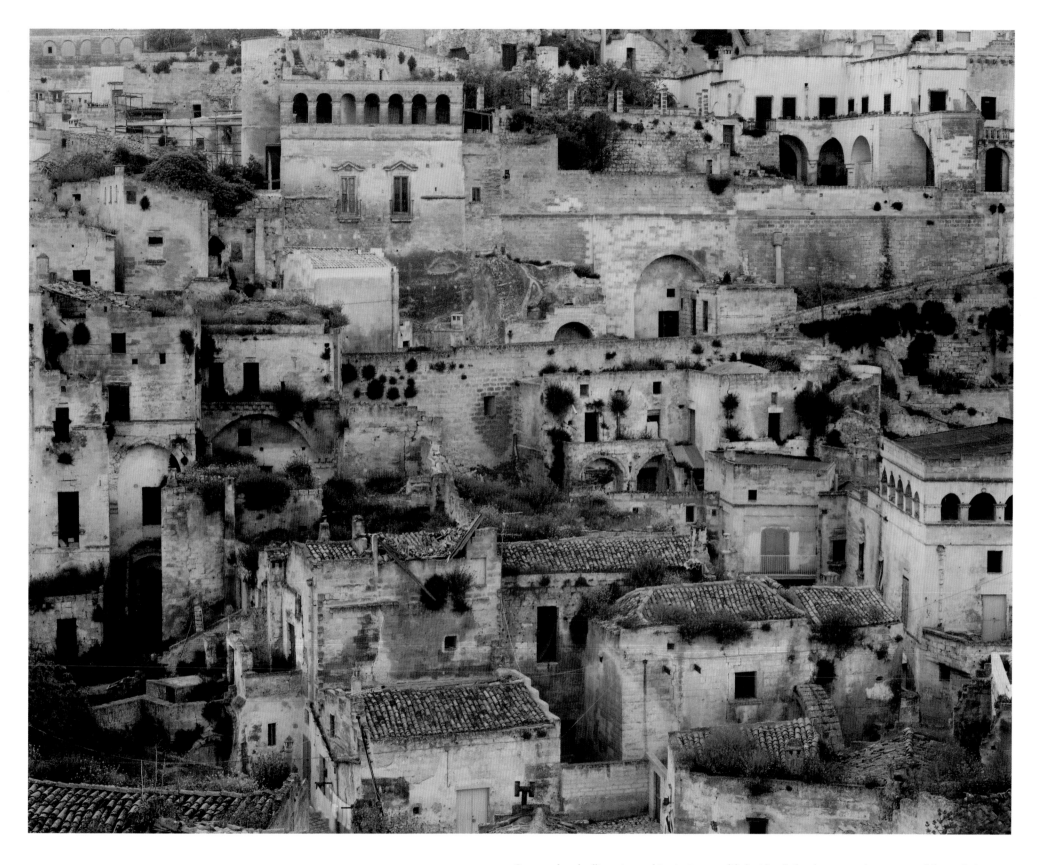

Caves used as dwellings since prehistoric times, modified with tufa façades, now under restoration, Matera, Italy, 1994

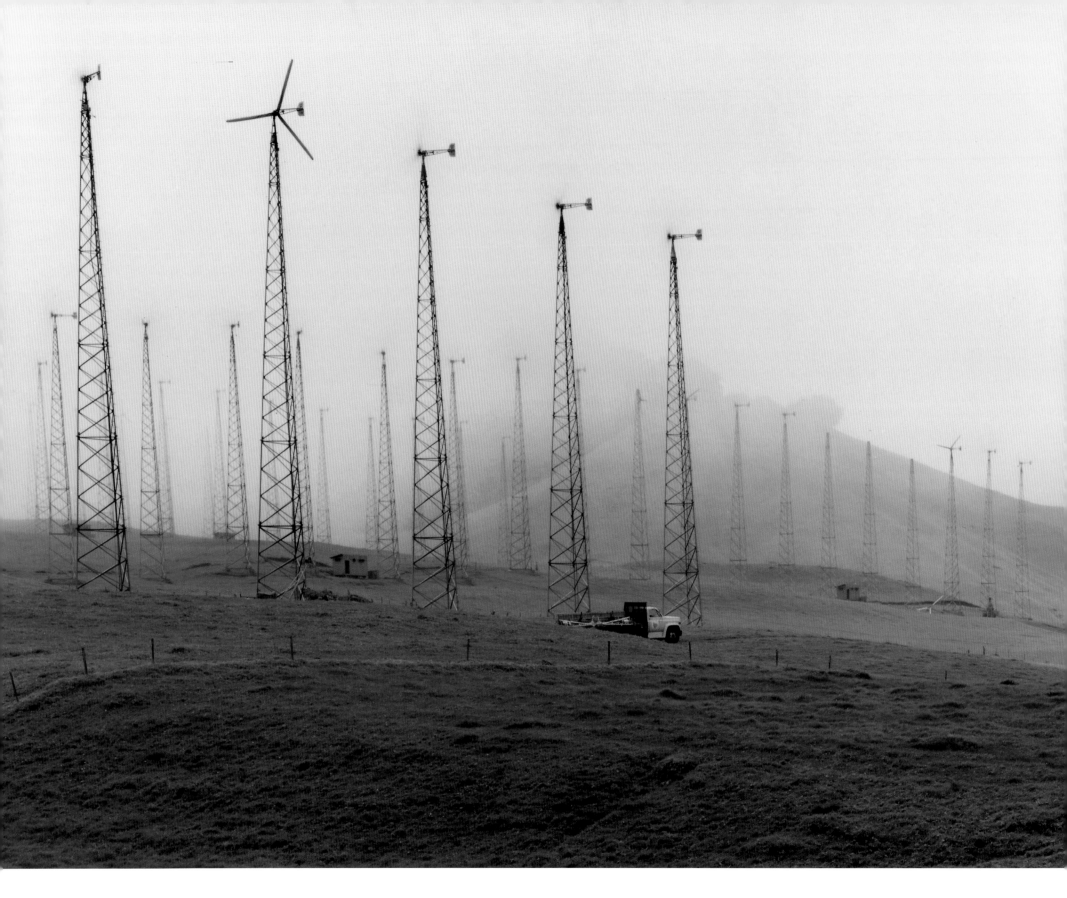

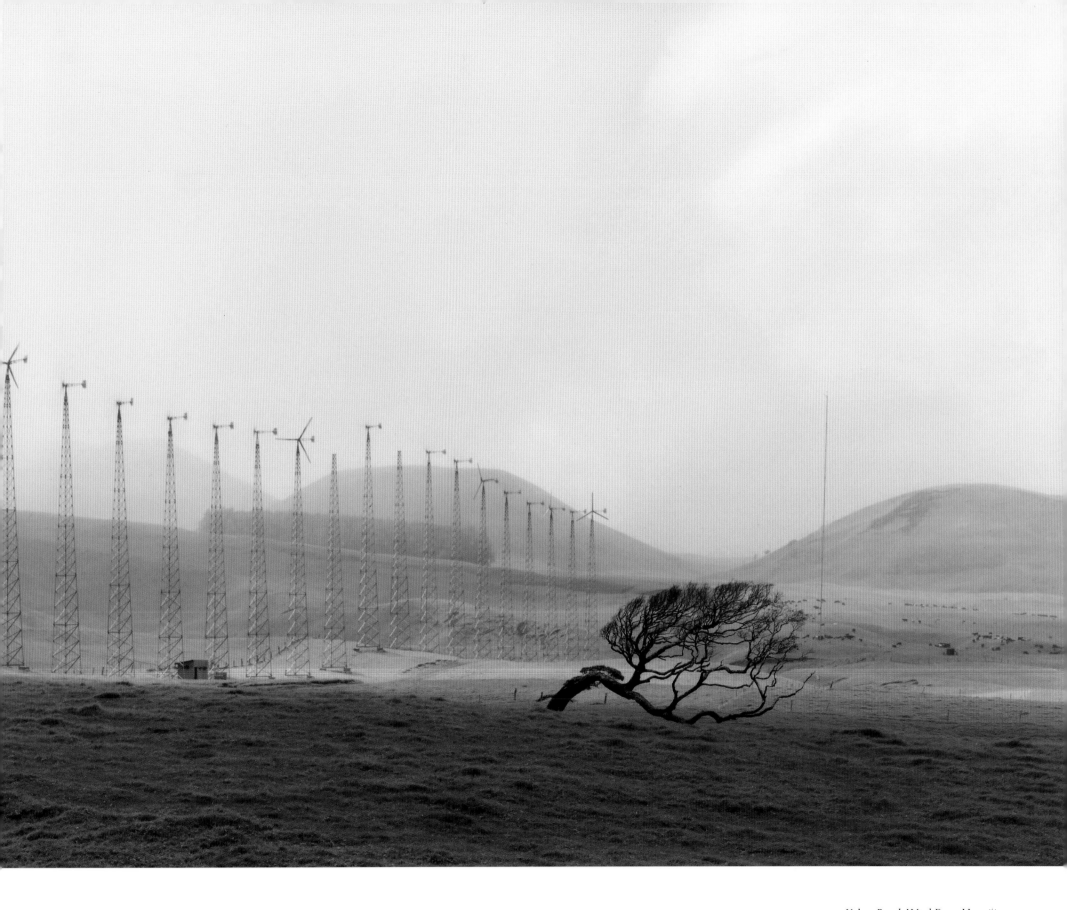

Kahua Ranch Wind Farm, Hawai'i, 1990

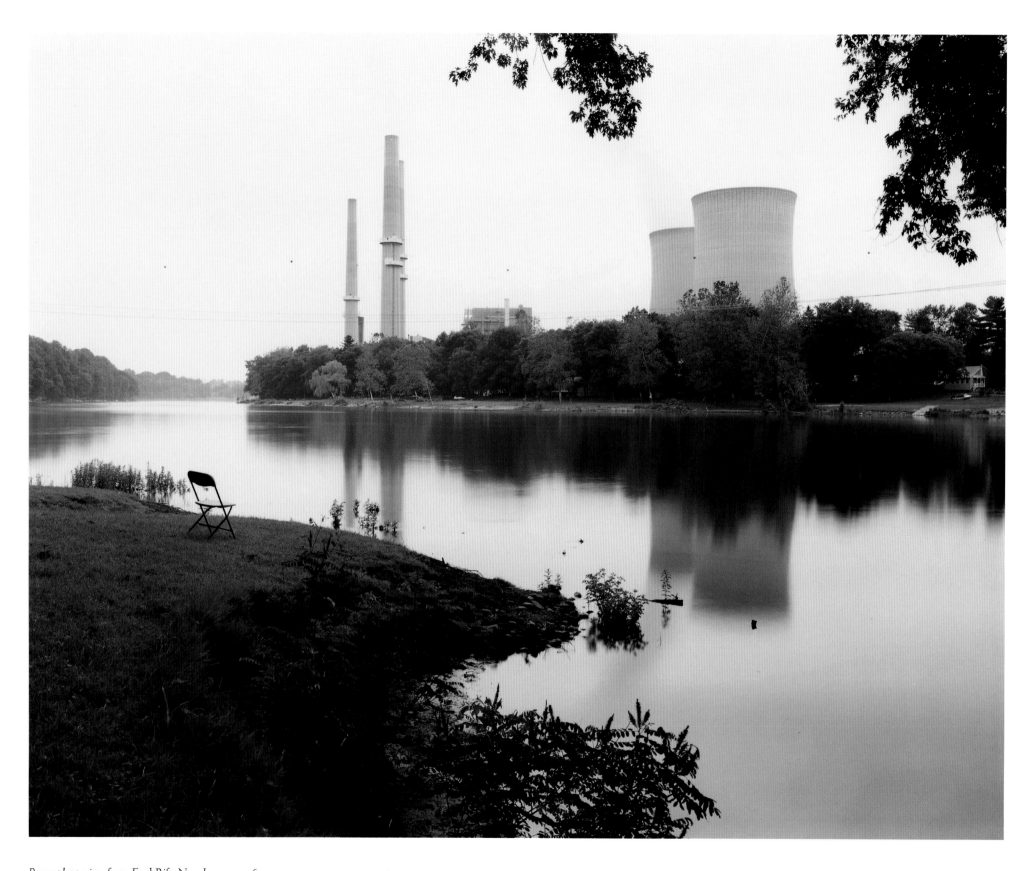

Power plant, view from Foul Rift, New Jersey, 1996

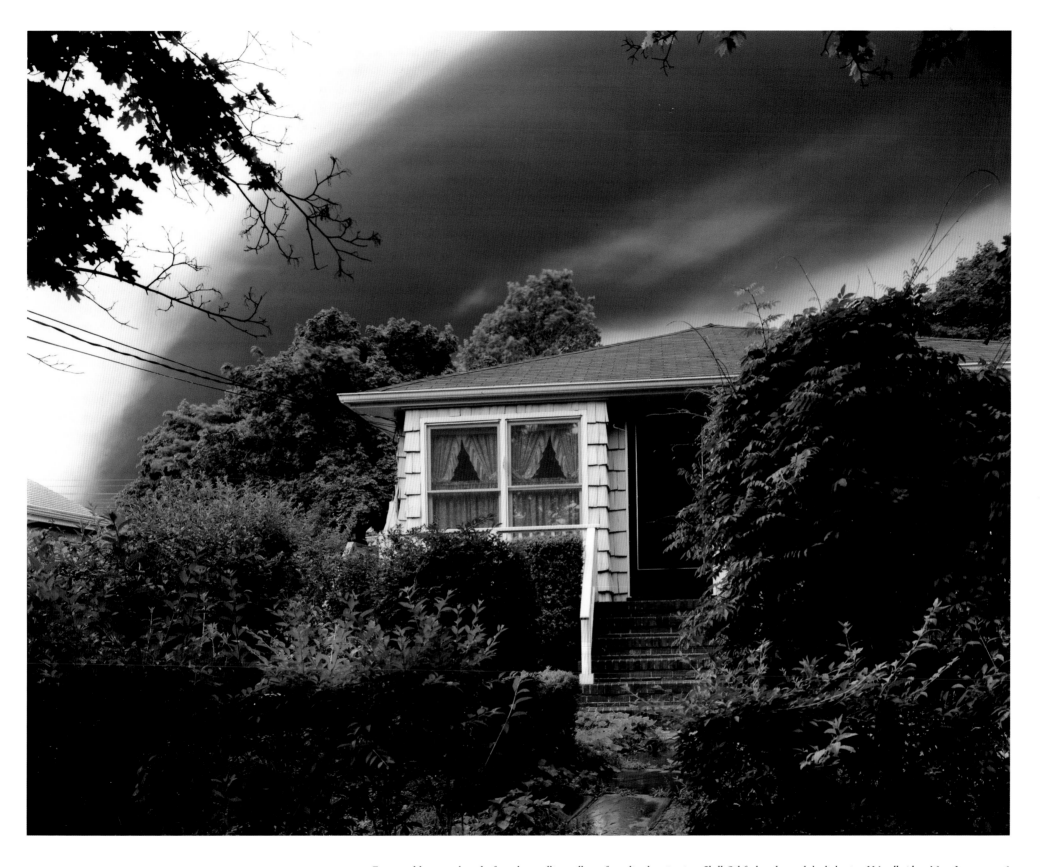

Evacuated house and smoke from three million gallons of gasoline burning in a Shell Oil fuel tank struck by lightning, Woodbridge, New Jersey, 1996

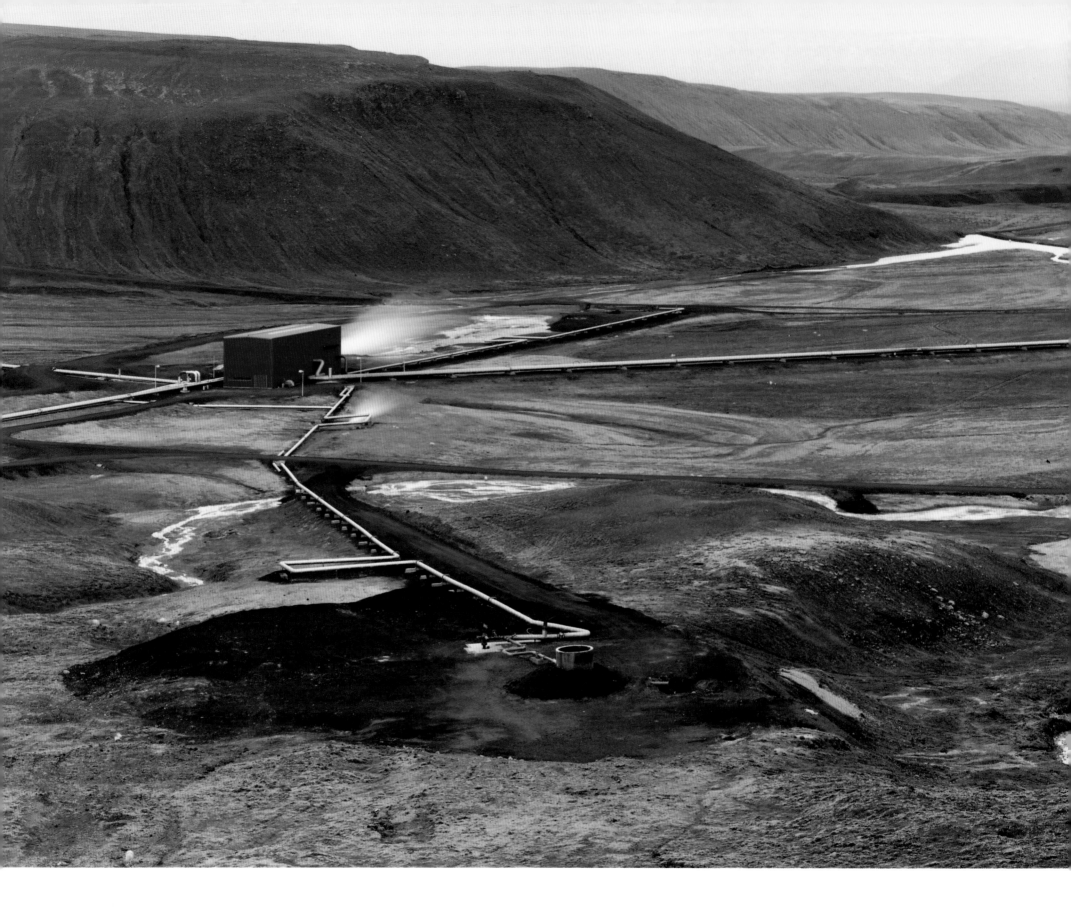

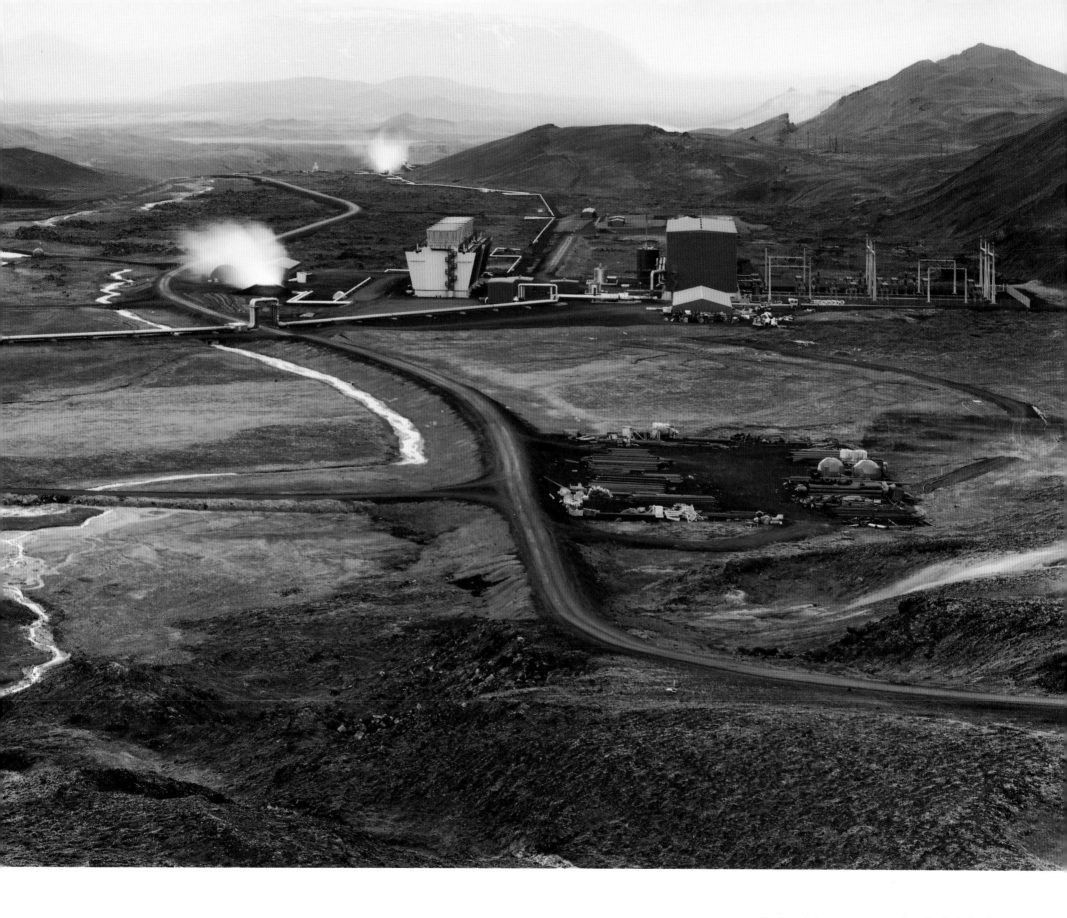

Geothermal electricity generating plant, Krafla, Iceland, 1987

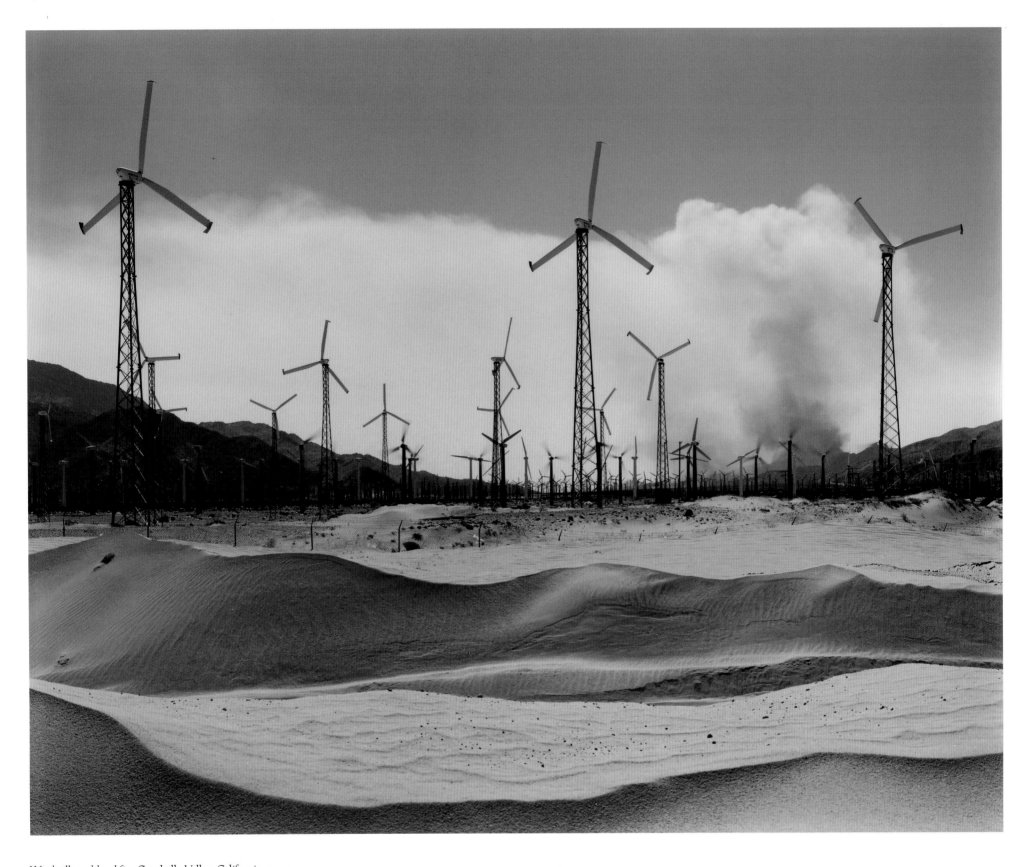

Windmills and brushfire, Coachella Valley, California, 1995

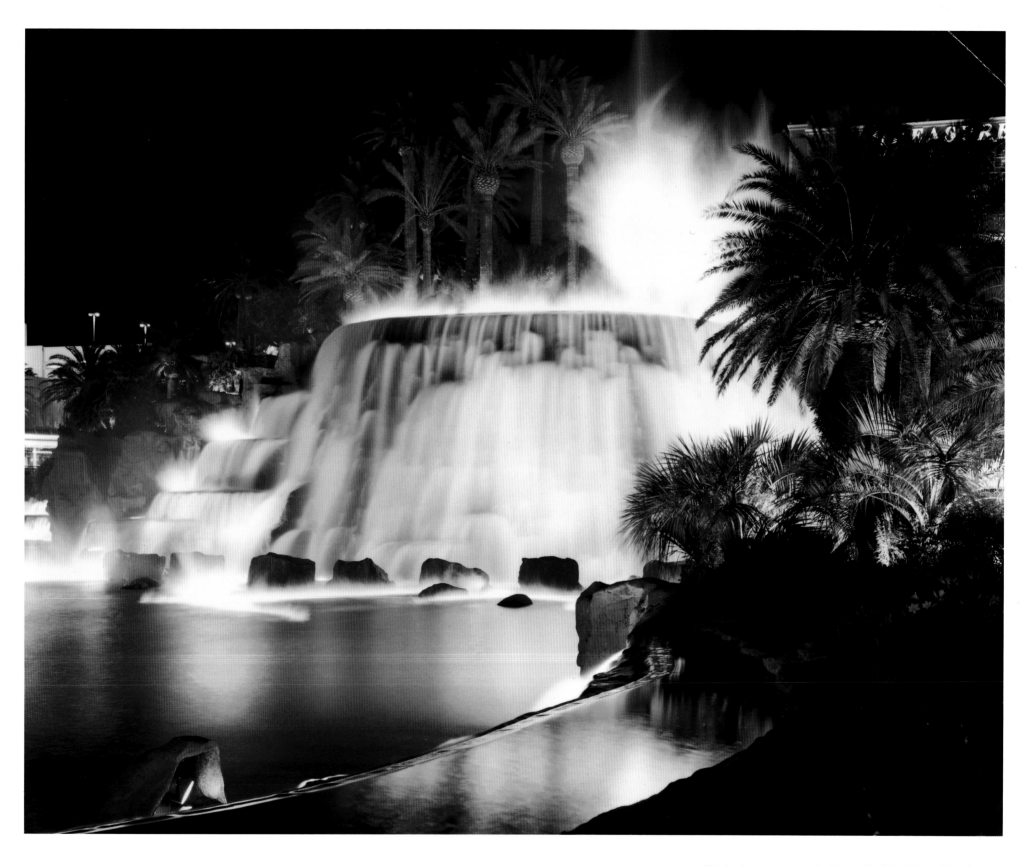

Artificial volcano erupting at the Mirage Hotel, Las Vegas, Nevada, 1995

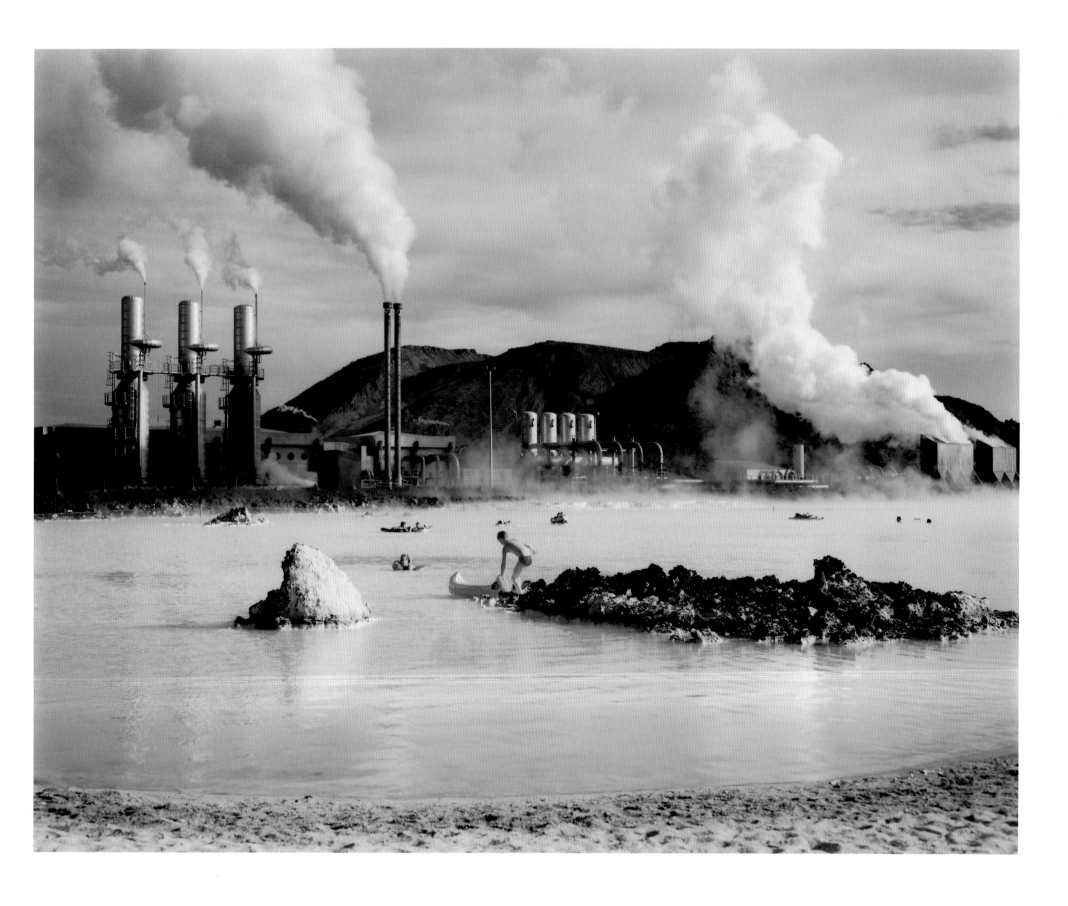

The Blue Lagoon, Svartsengi geothermal hot water pumping station, Þorbjörn, Iceland, 1988

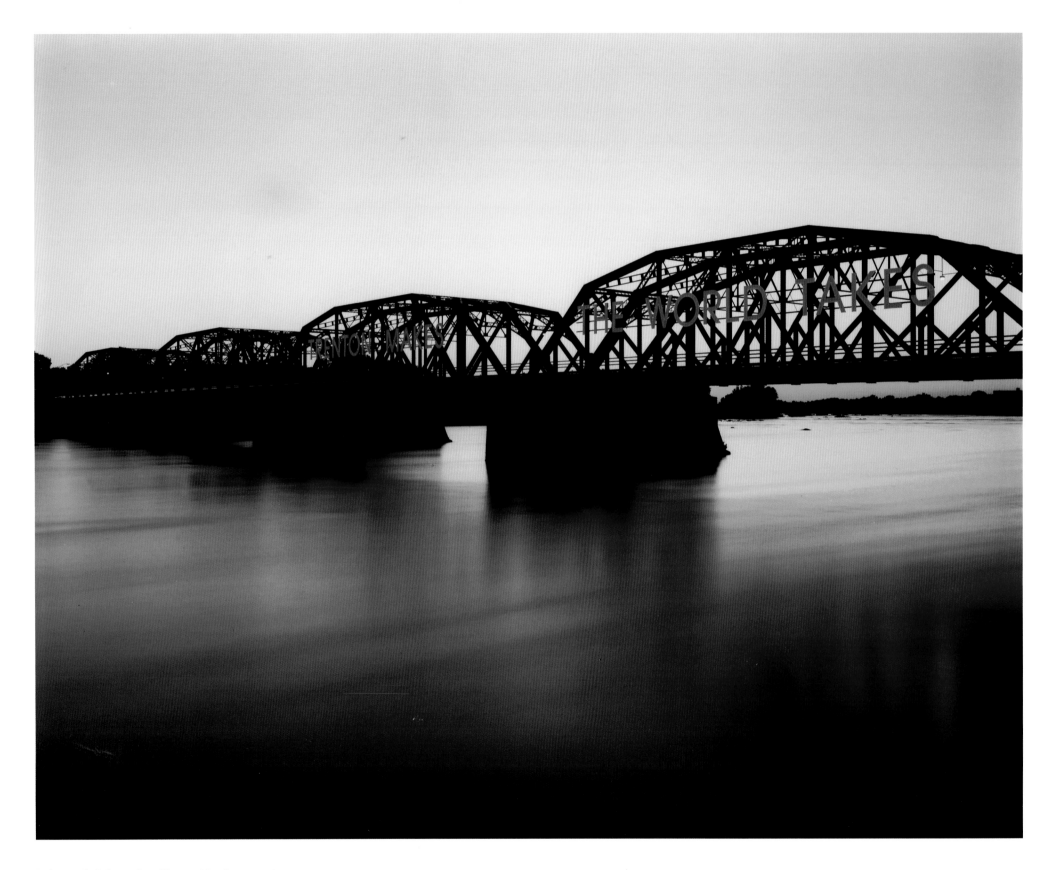

Bridge over the Delaware River, Trenton, New Jersey, 1996

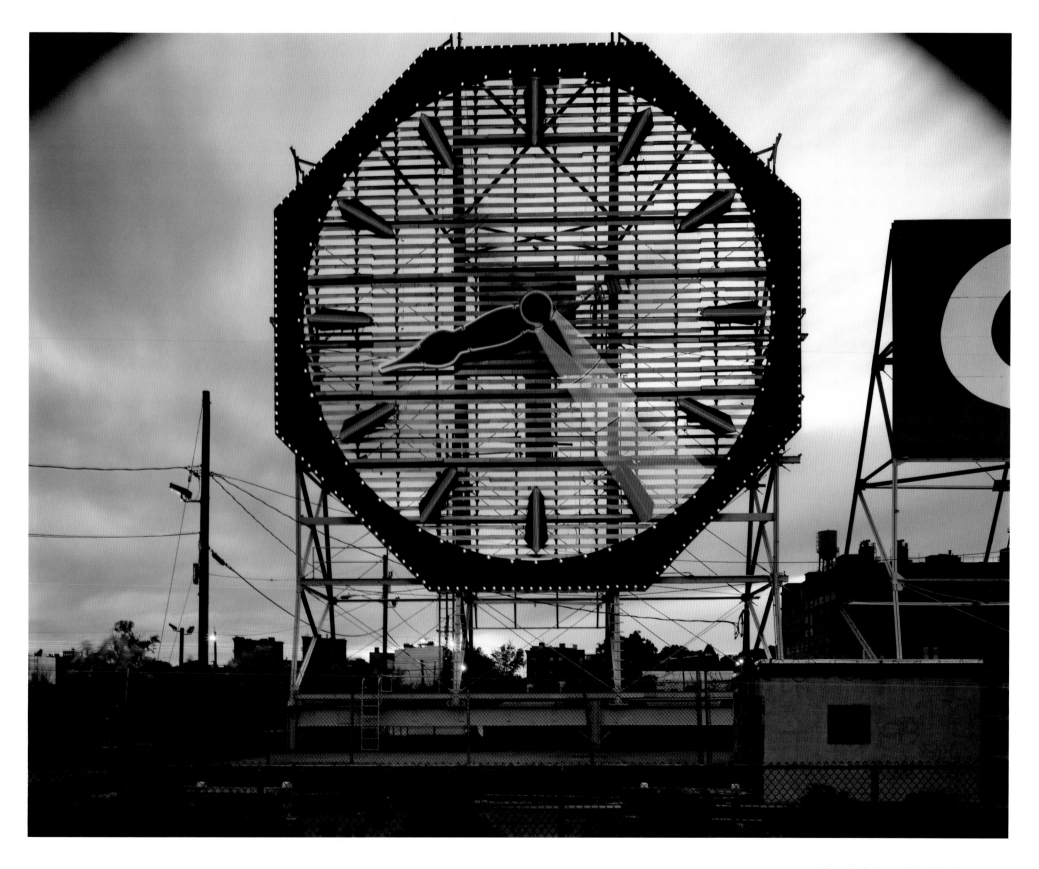

Colgate clock, Jersey City, New Jersey, 1997

Laura & Virginia

John McPhee

Under the dark cloth, Laura and Virginia talk. As dialogue goes, it is not memorable.

"Make sure you're happy with the edges."

"Do you want to use the longer lens?"

"The ten-inch is fine."

"The shutter is closed."

"It's cocked."

"Side-to-side level seems fine."

And yet, with luck, the collective effect can sometimes be more than memorable—a single creative photographic leap, done by two people.

They are in there together, bent forward, tandem, looking at the ground glass, their four legs sticking out below the cloth. The image they see is upside down and backwards but does not appear that way to them. In their mind, it turns, and flips.

"I like the fact that it's slightly asymmetrical."

"The shape bothers me."

Their own appearance, under the cloth, with the snout of the big camera protruding, is so incongruous and vaudevillian that snap-shooters the world over have crowded in to take pictures of Laura and Virginia making pictures.

Their collaborative landscape photography dates from 1987. Everywhere they have been, they have routinely visited botanical gardens, seeking not images but regional insight. They have never made a photograph in such a place, until today.

This is the Bronx, the New York Botanical Gardens, the recently renewed Enid A. Haupt Conservatory, and Laura and Virginia are under the dark cloth below the doming center of seventeen thousand panes of glass. They have been attracted by a black circular pool, forty feet across, among jelly palms, saw palmettos, Mexican flags, and crepe ferns. The box-like mahogany camera—a cubic foot and eighteen pounds—inclines toward the water from its tripod to comprehend the reflection of fronds, mullions, clouds, and sky. A visitor—a

tourist, a stranger, with a 35-millimeter camera hanging from his neck—comes up politely and asks first if he is in the way, if he is in the picture. To be in the way he would have to be swimming. He has sensed that he is in the presence of an unusual camera but has no idea what it is or what it is looking at. He asks me because Laura and Virginia are unavailable under the cloth and mostly out of sight. My expertise in this matter is only marginally greater than his, and derives solely from the fact that Laura is my daughter. When she was in college, I carried these big cameras up more than one pyramid in Yucatan and have been wary of them ever since.

"It's a Deardorff," I say to him. "A view camera—the nineteenth-century, Mathew Brady sort of camera. The negative it makes will be sixty times the size of a negative from yours. The things it captures are amazing. You're OK, the lens is aimed at the water."

It is not unusual for Laura and Virginia to spend a whole working day driving, walking, looking for images, setting up the camera, fixing its lines with a carpenter's level, chattering under the cloth, making "tilts and swings" and "rises and falls," and not exposing so much as one sheet of film. If they do all that on a given day and open the shutter once, they consider the day successful. They carry a Nikon 35, the sort of camera that most people fire as if it were an automatic weapon, but Laura and Virginia just look through it as if it were a spotting scope, to select and plan images in a preliminary way.

For a couple of hours, they have been staring at the conservatory pool and things are not going well. Subtly, the obsidian water moves. Faint breezes touch it from the open doors and windows. Every three minutes, big misters come on hissing and the vapors stir the air. In their frustration, half an hour ago, Laura and Virginia took the camera down, set it up elsewhere in the building, studied an image, discussed it, spurned it, and returned to the black pool. Under trying conditions, the dialogue within the dark cloth is not wholly technical.

"You should have been a therapist."

"Think so?"

"Yes, but you would not have been able to stop giving advice."

Photographic collaboration tends not to happen, and the list is a short one from Hill and Adamson in the mid-nineteenth century to the married couple Bernd and Hilla Becher of contemporary times. Laura and Virginia, long ago, took two Deardorffs to Iceland, where they intended to use them separately. Laura had first seen Iceland the year before, with me, in pursuit of my work, which had to do with open fissures, a newly risen volcano, moving lava, and the fact that Iceland is a geophysical hot spot coincident at present with the spread-

ing center of the ocean. Its freshly generated landscapes are surreal. Nothing arrested her eye more than the apalhraun—black, jagged, unvegetated plains of rock. She returned to Iceland with Virginia, and they set things up on the apalhraun, and at warm pools with inflatable canoes beside geothermal pumping stations, and in the high winds of Krafla in the interior, where Iceland itself is spreading. Their ideas and subjects were so similar that one of them said, early in the journey, "Maybe we ought to work on this together," and their long collaboration began. Work they did in 1988 in Iceland is owned by, among other places, the Los Angeles County Museum of Art, the Houston Museum of Fine Arts, and the San Francisco Museum of Modern Art. It has traveled in collected exhibitions to Boston, New York, Philadelphia, Detroit, Saint Louis, Santiago, Tianjin, London, Prague, Cologne, Basel. Wherever the pictures go, people tend to show bafflement that two photographers can somehow make a single exposure, and they ask how it is done. They ask, over and over again, "Who pressed the button?" And even when they understand that "the button" is the least of it, they tend to remain curious and puzzled. Other artists are full of wonder, too. In Laura's words, "Nobody can believe that two women can go around collaborating for ten years in a field dominated by lone males."

Virginia Beahan and Laura McPhee met in an introductory photography class at Princeton, taught by Emmet Gowin in the fall of 1977. Laura was a sophomore. Virginia, then a high school English teacher in Pennsylvania, was auditing the course. Laura went on to earn an MFA in photography from the Rhode Island School of Design, and Virginia from the Tyler School of Art. Laura is a professor of photography at the Massachusetts College of Art. Virginia has taught at Mass Art, and also at Harvard, Wellesley, Columbia, and elsewhere. Neither one is hesitant with words. In the span of their collaboration, words by the tens of thousands, in every conceivable category, have been muffled by the dark cloth.

> "We work in a kind of shorthand now, after ten years."
>
> "You articulate ideas to each other that you would never articulate to yourself. The collaboration requires the view camera. It forces us to talk about things."
>
> "Our slow intentional way—the way we work—makes it possible for us to collaborate."

These are people whose act takes a long time to get them together. The light is right for them twice a day, and they never choose dawn. An exception once probed the rule, and the exception's name was Sierra Nevada, which rises like a trap door and faces east, where the sun never sets. If the Sierra wall is to be seen in raking light, it has to be at dawn. Laura and Virginia saw rusted relics of a 1940s Japanese-American relocation center lying in desert sage below the loftiest mountain majesties in the contiguous United States. They got up in the dark, grumbling, fuming, and set up the Deardorff on the fruited plain.

When working in New York or New Jersey, they consistently finish breakfast by noon. At two, they are moving; their day has begun.

> "At first, it's frustrating. We look at a lot of stuff, reject most of it, and get depressed."
>
> "Then things start to open up."

A few days ago, they walked in Central Park all afternoon.

> "The park is so beautiful and so thought out you feel how every curve and hillock is there for you to get the vistas."
>
> "A lot of what we are looking for is surprise."

Bag the park. They have also been doing rooftops, which require planning.

> "This is a new thing for us—arrangements, appointments. We like to be loose."
>
> "New York is a big lotta work."

A roof in the West Twenties was wooden-decked in five levels, had an outdoor shower, a breeze-activated paper goose, a breeze-activated paper loon, concrete dogs, frogs, rabbits, and squirrels, and a rich ecology of real trees, plants, and flowers in sixty tubs, planters, pots, and urns. The roof had teak furniture and had been used as a movie set.

The Empire State Building, a few blocks away, was so immense it was threatening. They turned their backs on it, and let the view camera peer through the vegetation, the wildlife, and twenty-five rooftop water towers spaced out like chessmen and all but obscuring the World Trade Center, three miles south.

> "I don't even like those trade towers."
>
> "Maybe we can get rid of them entirely."

On a roof close by the western pier of the Brooklyn Bridge, they turned slowly and assessingly through an almost circular view: the South Street Seaport ("Tourist agenda"), the Fulton Fish Market ("Funky"), the legendary skyline of lower Manhattan ("Corporate clump").

> "The light on the Brooklyn Bridge is soft but dimensional."
>
> "The bridge is so seductive; no matter what you look at, you come back to it."

The camera has various component parts, and to some extent the photographers build it every time they set it up. The lens on its lens

board fits into the front standard. The rear standard includes the ground glass—a lightly gridded window exactly the size of the film. The front and rear standards are connected by the accordion-pleated bellows, and all of it rests on the bed, which fits onto the tripod. A system of threaded adjusters give it more than a little kinship with a surveyor's transit. Aim a 35-millimeter camera up the side of a tall building and the film sees a trapezoid. Fiddle with the knobs on a Deardorff and it sees the building as it is. Tilt the lens a little too much and the edges of the exposure will shade off and become opaque— an effect known as vignetting. L.F. Deardorff & Sons, of Chicago, has been making view cameras since the nineteenth century. Laura and Virginia's is forty years old. Its present value is about two thousand dollars. Its lenses cost a thousand dollars apiece. The film costs about seven dollars a sheet.

There were whitecaps on the East River, and once the view camera had been set up, leveled, and adjusted, it tended to wobble in the wind. Although the dark cloth is weighted in its four corners, it flapped when they conferred beneath it.

"Think about color. There's a certain palette here that's hard to break up."

"The white shape in the foreground bothers me."

"Stop. Stop. Go back a touch."

Pleased by what they saw in the ground glass, they stood up side by side, pulled out of the film holder the dark protective slide that covers the film, wrapped the cloth around their shoulders as if they were a pair of living tent poles, opened the shutter for twenty seconds, and successfully shielded the camera from the wind.

You could compile a list of the view camera's negative aspects. With the tripod and extra lenses, the whole apparatus weighs more than fifty pounds, and the ground over which they have backpacked it has included sharp lava. Their film travels heavy in a duct-taped Coleman cooler with ice packs wrapped in towels. In addition to dust, Laura and Virginia have seen black flies flying around inside the camera. On a footbridge by the falls in Paterson, New Jersey, the camera shook from pounding water. Heavy traffic vibrates it. To load film, they must be in total darkness. With black-plastic sheets, they blacken the interior of phone booths. They blacken closets. A motel room takes at least an hour. But nothing on the list approaches the challenge of wind.

At Krafla Geothermal Electricity Generating Plant, in Iceland in 1987, it was difficult enough for the photographers to remain standing, let alone the bulky camera, in a wind that was bevelling fast-rising steam. Two passing Germans, father and son, helped Laura and Virginia fashion a plastic tent, and the four of them, straining, held off the wind. In Sparanise, in Italy in 1994, a wind blew in such concentrated gusts that it stirred blossomed branches in one part of a cherry orchard into cloud-like swirls, while trees close by were motionless, doing the photographers more than a favor. In the middle of Pearl Harbor, in 1996, they set up the camera on the memorial above the USS Arizona, but nothing they tried could overcome the wind, and they packed up defeated. ("It was almost as if there were a force that didn't want us to make that picture.") In Sewaren, New Jersey, in January, 1997, they had me along with them so they could show me the true beauty of my native state, and a winter wind was blowing. Their discerning and composing eyes, which had circled the earth, had become strongly attracted to the New Jersey Turnpike, and to the commingled industries and residential enclaves that lie in the flats between the turnpike and the Arthur Kill. On Elf Road, in Sewaren, they found a concrete pier of a Conrail overpass that had become a stone monument three stories high, bearing the names of forty-two dead rock stars: Buddy Holly 1959, Big Bopper 1959. . . . Jimi Hendrix 1970, Janis Joplin 1970. . . . Elvis Presley 1977, Keith Moon 1978. . . . In their slow, intentional way, they set up the camera and composed their picture with a deliberation worthy of a great river or of skaters on a Dutch canal, while the object in view of the view camera was an immobile hundred-ton slab. Watching and waiting in that New Jersey wind I found myself thinking, correctly, that I would be far more comfortable if we were doing this in Alaska. New Jersey's wet cold can shrink marrow. The camera on its tripod was shaking like a tree. Much of the waiting was for a moment of relative calm. The moment finally came, and while Laura and Virginia held taut the dark cloth like a shielding banner, Laura counted "a thousand one, a thousand two," and on up as the film took in the light, and she inserted, between counts, gratuitous information for me: "Color film prefers to be overexposed." I prefer not to be and was absorbing nothing.

And now, indoors at the New York Botanical Gardens, wind should not be a factor, but even the lightest breath of air can move this nervous water. Twice, they have made exposures that they feel are imperfect. They are far into their third hour, much of it under the cloth, looking for stillness in the shining black reflection. To pass time, I walk around reading the small placards at the bases of trees. I learn that royal palms were named for nothing majestic. Genus *Roystonea*, they were named for Roy Stone. This information fails to enter-

tain Laura or Virginia. After another ten minutes in unacceptable air—with the misters on and the black pool a slightly quivering jelly—Laura says, "I can't deal with this, Virginia; it's driving me insane."

Virginia, reading incident light, has been discussing shutter speeds and *f*-stops. A Nikon's *f*-stops stop at 22. This lens goes to 90. Virginia gets back in under the cloth.

> Virginia: I do like the asymmetry.
>
> Laura: Where is it?
>
> Virginia: That's more like what I thought I was seeing.
>
> Laura: I can't believe we're taking yet another picture of this swamp.
>
> Virginia: What did you focus on?
>
> Laura: The palm at the end of my mind.

The misters, for the moment, turn off. The doors, for the moment, are closed. The air relaxes. You could light a match and the flame would not bend.

> "Pull it."
>
> Laura pulls the dark slide.
>
> "Do it."

Virginia moves to open the shutter, but a child near the edge of the pool throws a coin into the water.

Six P.M. on the Mosholu Parkway and in most people's days the equivalent is noon. In this summer light, dusk is still distant, but a faint sense of purpose has come into the air and the professional tempo has abandoned zero. Laura and Virginia taking a picture is analogous to my making notes. Until they see a print, they don't know what they've got. While aiming in a general way at New Jersey, they are reviewing the afternoon's effort and calling it a scarlet macaw.

In Costa Rica, in the rainy season some years ago, they were finding no images they wanted to take home with them, and day after day passed while conditions failed to improve. Eventually, in their frustration, they set up the Deardorff and tried to make art of a red bird tethered to a stainless steel tree. This was the one exposure they made in nearly a week. When they looked at the result, they were not surprised by its absolute lack of redeeming value, and the scarlet macaw became for them a symbol for a bad idea resulting in a bad picture.

A voice in the back seat says, "So why don't you give up the Deardorff and settle down with your Hasselblads?"

They shoot back:

"Because of what it sees."

"The quality of description invites slow looking."

"It sees more than the eye would see—a whole view in incredible detail."

"Every hair. Every blade of grass."

From the eighty-square-inch negative, they can achieve that level of detail in a print exceeding eight square feet.

Under the dark cloth, when they look at the ground glass, eight by ten, in effect they are looking at the negative they are making. Much as copilots say to each other, "Wheels down," "Down and locked," Laura and Virginia say repeatedly, "Check the edges of the picture." Do they ever crop?

"Rarely but not never."

"Part of the pleasure of making a picture is getting it right in the frame."

"When you crop it, it's never quite right."

When they study the ground glass under the dark cloth, they are cropping the landscape rather than the picture. They use an eight-power loupe, which looks like a big jeweler's lens, placing it on the ground glass, and looking through it to improve the precision of the focus.

When they count a thousand one, a thousand two, they seem by comparison carefree and vague. Time is as casual as focus is precise. If the light meter suggests four seconds, they'll double it. Thirty seconds—they'll give it a minute. If your lighting of choice is the late, raking kind and the various glooms that follow, you need to give the camera a long slow draught. To exposures of less than a thousandth of a second and exposures of one second or more the photochemical law of reciprocity does not apply. The product of light and time is not constant. Known as reciprocity failure, this phenomenon (or lack of one) tends to detach from technology the photographer who wants to work in low and failing light. Improvisation enters the equation. The procedure goes supple, like an inspired chef tasting everything and measuring nothing.

"It's like salt."

"You throw on a few more grains."

"As we told you, better over than under."

"With color film, underexposed is the kiss of death."

They made a fifteen-minute exposure of an artificial volcano erupting water in Las Vegas. Virginia, all the while, was on patrol, intercepting passers-by, trying to prevent them from walking in front of the camera. She failed to see an infiltrating Asian tourist, who reached the camera and stared straight at it from a distance of ten inches.

"He's got his nose in our open lens!" Virginia screamed, and ran over to shoo him away. Shutter open, the camera went on looking at the volcano. The exposure was such a long one that the man did not show up in the picture, which belongs to the art museum of Princeton University.

During a twenty-minute exposure at a reservoir in Costa Rica, power boats and wind surfers moved in and out of the picture, but when it was developed they weren't there. During a long exposure over plunging sluices at a reservoir in Sri Lanka, big white ibises flew in and out of the picture, but when it was developed they weren't there.

While Laura and Virginia were making a slow exposure of a chaparral fire in California, a line of prisoners, in orange fire fighting suits, walked through the picture from left to right but escaped being caught on film.

In the Aeolian islands, they opened the shutter for an hour and a half on the real Stromboli erupting. While they waited, they went for pizza. The darkly outlined final product was brightened by motion: by the shifting stars, by the flashlights of hikers, by the ninety-minute brushstroke of the moon.

They cross the George Washington Bridge to New Jersey and go north on the Palisades Parkway to Rockefeller Lookout in Englewood Cliffs. From the river the rise is sheer, two hundred feet, to the brink where they set up the camera, after climbing over a protective fence. This is one of the New York views that belongs in Category 1 with the view over the water from the Staten Island Ferry near Richmond and the view from the summit of the Throgs Neck Bridge. Past the Bronx and Yonkers, the reach upriver extends at least twenty miles. Directly opposite, the drawbridge is open in the Spuyten Duyvil, stopping the toy trains. Downriver, the great bridge brackets the receding city—Morningside and Midtown and the Village valley and Wall Street. What they see in the ground glass is a fifty-fifty ratio of concentrated city and tree-covered diabase—palisade cliffs, with a fjord running through. In their constant search for the dividing lines between altered and unaltered worlds, this scene is at mid-spectrum.

The river lies on a fault, I contribute. The rock on the two sides is in all respects different, and the New York side is a billion years older. With loupe and level, Laura and Virginia are speeding up. On the cliffside, the falling light has turned half of the crown of one young maple gold. "We're going to lose that in about a minute—that tree. We're going to lose that light." They let the camera soak it in for three minutes. Virginia, as she waits, expresses some regret that the film is not Fuji. It is Kodak Vericolor, which she says is "very natural," but she mentions "the acid green of Fuji," and its "intense saturation of color." Looking down the river at the city, she adds, "A soft shot like this, the Fuji might juice it up."

Virginia lives in New Hampshire and has a daughter, who has just finished college. Laura has a daughter in the Class of 2017. Virginia's husband, Michael Beahan, is director of audio-visual services at Dartmouth College. Laura's husband, Mark LaPore, teaches filmmaking at Mass Art. The collaborative rambles of Laura and Virginia happen when they can.

We drift south, toward Jersey City, for a rendezvous at sunset with the Colgate clock. Funded by foundation grants, their pictures are from Iceland, Costa Rica, Hawaii, Sri Lanka, southern Italy, southern California. Why New Jersey?

"We both grew up near Trenton."

"It's a landscape with the aspect of memory."

"We want it in our book."

In Trenton, the Deardorff spent ten evening minutes drinking in the Bridge Street bridge. Anyone who grew up near Trenton, as I did too, will accord that bridge the aspect of memory, with its bathetic letters that all but span the Delaware: TRENTON MAKES THE WORLD TAKES. The long exposure glossed the river, turned it into delinear frosting.

The allure for them of Carteret and Rahway is shared, safe to say, by no one else passing through on the turnpike, but they see in its refinery tanks and residential streets a "fantastic landscape"—in a phantasmagorical sense "a landscape of dreams." They even compare Carteret to Hawaii. In the lava fields of Kilauea, among the record outpourings of recent times, are isolated parcels of spared ground called *kipukas*—a few acres, here and there, that the lava has so far missed. On some of these are surviving houses with people still in them. Instinctively, Laura and Virginia were drawn off the turnpike and into the kipukas of Carteret, where bungalows with picket fences survive the industrial magma.

"People are in a place."

"The place changes around them."

"They don't leave."

One summer evening, parked at such a place, they were waiting out a thunderstorm and planning a picture that would include both the pickets and the Port Reading Refinery. As they studied the background, a bolt of lightning came down through it and a huge black cloud shot to the sky. The lightning had ignited three million gal-

lons of gasoline. While the black smoke rolled overhead, they made their picture.

The Colgate clock is half a mile south of the Holland Tunnel beside the slip of a ferry to Manhattan. The view across the water to Wall Street is, easily, in Category 1, and now, at 8 P.M., a hundred thousand Wall Street windows are glistening copper. The sun is so low over new Jersey that its westward raking light must be feeling for Hokkaido. Its easterly rays backlight the big clock through a frieze of rooftops, tree crowns, razor wire, and chain link, described by these photographers as "a tableau of urban living." Like a ferris wheel, the clock is an open, skeletal structure—an octagonal analog time-piece with hands thirty feet long. As dusk arrives, the hands are illu-minated in red neon streaks, and the whole three-thousand-square-foot face is surrounded by rows of white light bulbs.

Laura and Virginia have climbed a chain–link fence and set up the Deardorff on a crumbling slab of old pier. Three steps backward and they're in the river. Pressure rises. Police could break this up. The sun is vanishing fast. On this July night, the wind off the water is surprisingly cold. But the clock itself is the principal agent of today's crepuscular crescendo. They have chosen 8:20 as the optimum moment for opening the shutter, because of the drooping dihedral of the illuminated hands.

To lift the lens above the fence line, the tripod is fully extended, and one at a time they have to get up on the camera's storage box to see what is under the dark cloth. A ferry docks, and people walk by grinning.

"We have vignetting."

"Can we frame it differently?"

"All I want is to make sure we get an eight-by-ten out of this."

"With the vignetting we're in trouble."

"Maybe we'll like it."

"We need to level side to side."

8:15 p.m. "Cool. We're going to be right on schedule."

"I think this is going to be beautiful."

"I'm so happy for you."

Shivering, the two of them wrap themselves in the dark cloth, which consists of two heavy cotton layers—the inner one black, the outer one white. Virginia, standing on the camera box, removes the dark slide, and steps down.

"What do we want to do?"

"Three minutes."

"OK, three minutes."

"Pull it."

"Check the wind."

They unwrap themselves, open the shutter, and for three min-utes hold up the cloth against the wind. During the three minutes, a man and a woman, dressed Wall Street and approaching the ferry, walk right into the picture.

"It's OK."

"They won't register on the film."

Now the man and the woman slow down—in front of the camera, in front of the sixty-foot clock—and each one is tapping at a cellular phone.

Slowly, they leave the picture, with a full minute to go.

"So there was a piece I was reading last night about a couple who wrote together and about the terrors of collabo-ration."

"So they got divorced?"

"They discovered that two heads are better than one."

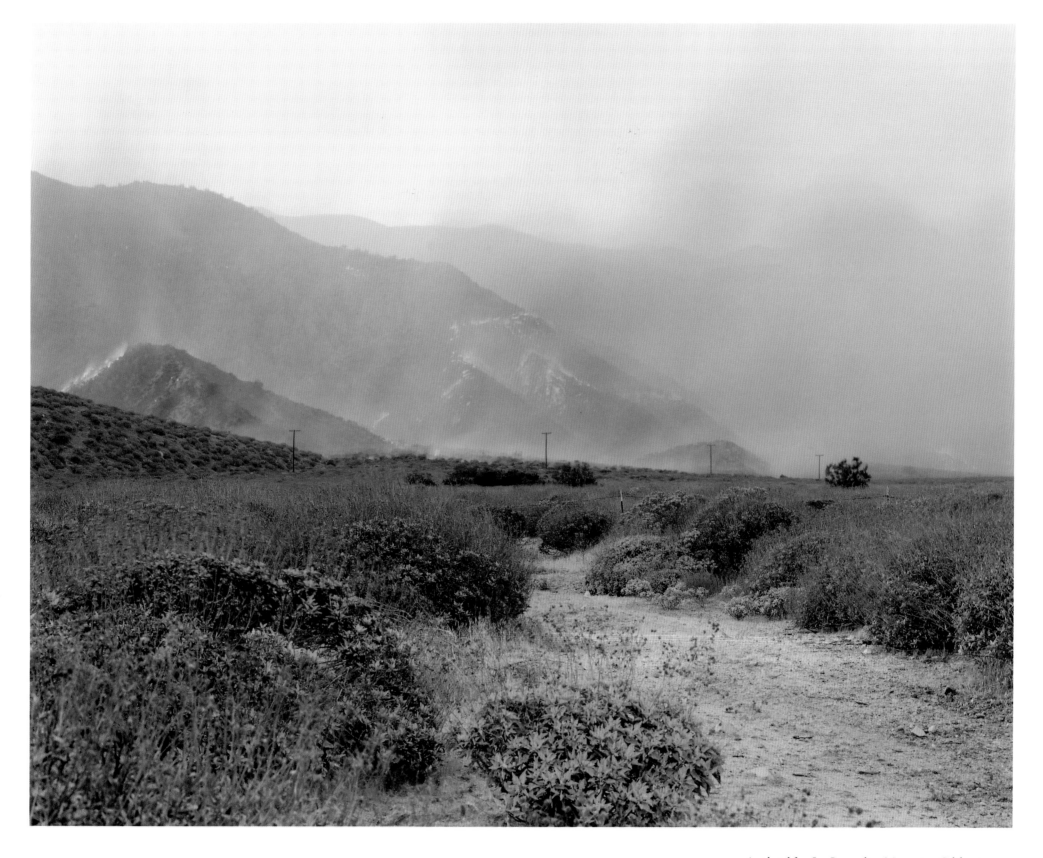

Accidental fire, San Bernardino Mountains, California, 1995

ACKNOWLEDGMENTS

First we would like to express our gratitude to the many strangers who have helped us along our way. We could not have made this work without the trust and empathy of dozens of individuals who opened their homes, gave us keys, organized official permissions or looked the other way, suggested points of interest, waited patiently while we talked, observed, and photographed. It is almost impossible for us to remember a circumstance in which we have been told definitively "no." In every landscape, no matter how remote or populous, we have met people who have been helpful and kind and who have wished this project well. We could not have proceeded without them.

Closer to home, we would like to thank our friends and colleagues for their generosity and encouragement. We have learned so much from these people: Jacquie Strasburger and Jim Dow; Emmet and Edith Gowin; Frederick Sommer; Gary Metz; Susie Cohen; Abe Morell, Barbara Bosworth, Johanna Branson, Judy Haberl, and Nick Nixon at the Massachusetts College of Art; Toby Jurovics and Peter Bunnell at The Art Museum, Princeton University; and John Jacob, Director of the Photographic Resource Center. Susan Stoops and Carl Belz at the Rose Art Museum at Brandeis University were instrumental to the development of this body of work; their clarity of vision and their ongoing support have been indispensable. Bob Korn of Cape Light has been another important member of our collaborative team. Linda McCausland's hospitality and warm spirit have been crucial to us. For the interest that Laurence Miller, Susanna Wenniger, and Vicki Harris of the Laurence Miller Gallery in New York and Rose Shoshana at the Gallery of Contemporary Photography in Los Angeles have shown in our work, we are very grateful.

We are lucky to have had many years of friendship and conversation with people who have taken a serious interest in our pursuits: Katrina vanden Heuvel gave Laura the Deardorff with which all of this work was made; Barbara O'Dair and Frank Gadler; Joan McPhee and Michael Gilson; Sonia Sultan; Dayle and Bob Walden; Pat and Phil Klein; Greg and Nadia Gorman; Ed and Becky Gray; Ed Grazda; Barbara and Tim Healey; Michael Pitkow and Jane Schreiber; Lewis Klahr and Janie Geiser; Mark McElhatten and Arielle Greenberg; Fred and Kato Guggenheim; Faith Catlin and John Griesemer; Fazal Sheikh; Sage Sohier and David Feingold; Anya Hurlbert and Matt Ridley have all made contributions of one kind or another to this work. Stephen Murray encouraged our collaboration at this project's inception and he remains one of our greatest champions. Thank you.

Certain essential assistance was offered in Iceland by Sigurdur and Helga Steinthorsson; in Hawaii by the Rangers at Volcanoes National Park and by Robin Sanders; in Costa Rica by Steve Tourlentes who shared his knowledge of that country freely and Alane Brodrick who was brave enough to accompany us; in Sri Lanka by Duncan MacInnes of the United States Information Service and by his wife Donna Ives, by Arjun and Dipika Dharmadasa, and by Anne Sheeran; in Italy we wish to remember la famiglia Sgarilia at the Villa Vergiliana; in California Rod and Kyle Boone, the Channel Coast District Parks and Recreation Department, the Mono Lake Committee, and Gibby for her welcomes and her incredible cooking and company. In New York and New Jersey we have been fortunate to have received all manner of consideration and hospitality from Andrei and Maria Derevenco and from Laura's immediate family who have shared their homes with us: special thanks to Pryde Brown, Yolanda McPhee, Martha McPhee and Mark Svenvold, Jenny McPhee and Luca Passaleva, Sarah McPhee, and Joan Sullivan. We would also like to remember Dan Sullivan, a source of ideas, humor, and encouragement, who died while this was still a work-in-progress. Jeanne Cadwallader, John Cadwallader, and Maureen Sullivan have offered their unerring support. Virginia's father, Alvin Cadwallader, who passed away just before this book was published, imparted to her his interest in maps and geography, and his profound curiosity about the world.

We have many people to thank for their help in the production of this book: Sarah Chalfant of the Wiley Agency has amazed us with her profuse encouragement and her stalwartness; we also wish to mention Andrew Wiley and the tireless Jin Auh. We appreciate the generosity of Kathy Hart of the Hood Museum, Steve Turner of the Smithsonian Institution, and Joyce Ryerson from the Baker Library Map Room at Dartmouth College. We want to thank the staff at Aperture and especially our editors: Ron Schick for understanding and embracing this project, Michael Lorenzini who stood by us in the doldrums, and Lesley Martin for her intelligence and hard work. Thanks also to Steve Baron, Michelle Dunn, and Wendy Byrne for their expert help with design and production. This book would not have happened without the extraordinary generosity of Rhett Turner and the Turner Foundation.

The writers who have contributed to this book add enormously to its value. Rebecca Solnit's thoughtful, insightful introduction is a deeply appreciated contribution which beautifully articulates ideas about the indivisibility of nature and culture—the organizing principles of this work. John McPhee's afterword, a more concrete examination of the nuts and bolts of our collaboration, offers answers to questions people often ask us. He replies more eloquently than we could ever hope to. We are indebted to him for taking an interest in following us on a few of our peregrinations.

Our work has been supported with generous financial assistance from many sources including the John Simon Guggenheim Memorial Foundation, the New England Foundation for the Arts, the Pennsylvania Council on the Arts, and the English Speaking Union. To all these institutions, we are eternally grateful.

Most important, we would like to thank our immediate families who have believed in us over the last decade. Virginia wishes to thank her husband Michael for providing the mooring from which all departures originate: he has been selfless in his support of this project which has continued much longer than anyone anticipated. Her daughter Christina has embraced the making of this work with unconditional enthusiasm; she is a kindred spirit whose humor, resourcefulness, and sense of adventure have been essential. Laura thanks her husband Mark LaPore for his continuous and patient viewing of this work over the years and for using his wonderfully critical eye to foster what is best in these photographs. Her daughter Isobel has been a source of joy and inspiration and at two is already an intrepid travelling companion. It is to these four people that this book is dedicated.

Copyright © 1998 by Aperture Foundation, Inc.; Photographs copyright © 1998 by Virginia Beahan and Laura McPhee; "Indivisibility" copyright © 1998 by Rebecca Solnit; "Laura and Virginia" copyright © 1998 by John McPhee.

The publisher and photographers gratefully acknowledge permission to reprint the following: Illlustration on the epigraph page from an engraving by Athanasius Kircher, *System Idaale Pyrophylaciorum Subterraneorum*, reprinted by permission from the Smithsonian Institution, epigraph copyright © 1987 by Barry Lopez, from *Arctic Dreams*, reprinted by permission of Sterling Lord Literistic Agency; p. 12, top: copyright © 1993 by Island Press, reprinted by permission from *Passing Strange and Wonderful: Aesthetics, Nature, and Culture*, Yi-Fu Tuan, bottom: p. 30, top: copyright © 1995 by Simon Schama, from *Landscape and Memory*, reprinted by permission of Alfred A. Knopf, bottom: copyright © 1998 by Gretel Ehrlich, reprinted by permission of the Darhansoff and Verrill Literary Agency; p. 50, top: copyright © 1990 by Edward Said, from "Yeats and Decolonization" in *Nationalism, Colonialism, and Decolonization*, Terry Eagleton, ed., reprinted by permission of University of Minnesota Press, bottom: copyright © 1995, Richard White, from "Are You an Environmentalist or Do You Work for a Living" in *Uncommon Ground: Toward Reinventing Nature*, William Cronon, ed., reprinted by permission of W.W. Norton & Company; p.74, top: copyright © 1992 by Alexander Wilson, from *Culture of Nature: North American Landscapes From Disney To The Exxon Valdez*, reprinted by permission of Blackwell Publishers.

Library of Congress Catalog Card Number: 98-84497
Hardcover ISBN: 0-89381-733-3

Book design by Michelle M. Dunn

Printed and bound by Sfera Srl, Milan, Italy

The staff at Aperture for *No Ordinary Land* is:
Michael E. Hoffman, *Executive Director*
Vince O'Brien, *General Manager*
Stevan A. Baron, *Production Director*
Lesley A. Martin, *Editor*
Helen Marra, *Production Manager*
Sara Federlein, *Development Manager*
Steven Garrelts, *Production Assistant*
Nell Elizabeth Farrell, Phyllis Thompson Reid, *Editorial Assistants*
Amy Lynn Santora, *Permissions*
Caryl Baron, *Design Work-Scholar*
Cara Maniaci, *Editorial Work-Scholar*

APERTURE FOUNDATION publishes a periodical, books, and portfolios of fine photography to communicate with serious photographers and creative people everywhere. A complete catalog is available upon request. Address: 20 East 23rd Street, New York, New York 10010. Phone: (212) 598-4205. Fax: (212) 598-4015. Toll-free: (800) 929-2323. Website: http://www.aperture.org.

Aperture Foundation books are distributed internationally through: CANADA: General Publishing, 30 Lesmill Road, Don Mills, Ontario, M3B 2T6. Fax: (416) 445-5991. CONTINENTAL EUROPE, UNITED KINGDOM, AND SCANDANAVIA: Robert Hale, Ltd., Clerkenwell House, 45-47 Clerkenwell Green, London EC1ROHT. Fax: 171-490-4958. NETHERLANDS AND BELGIUM: Nilsson & Lamm, BV, Pampuslaan 212-214, P.O. Box 195, 1382 JS Weesp, Netherlands. Fax: 31-294-415054.

For international magazine subscription orders for the periodical *Aperture*, contact Aperture International Subscription Service, P.O. Box 14, Harold Hill, Romford, RM3 8EQ, England. Fax: 1-708-372-046. One year: $50.00. Price subject to change.

To subscribe to the periodical *Aperture* in the U.S.A. write Aperture, P.O. Box 3000, Denville, NJ 07834. Tel: 1-800-783-4903. One year: $40.00. Two years: $66.00

First edition
10 9 8 7 6 5 4 3 2 1